IMAGES
of America

THE AMERICA'S CUP
YACHTS
THE RHODE ISLAND CONNECTION

VOL. XXXVIII. No. 965. PUCK BUILDING, New York, September 4th, 1895. PRICE 10 CENTS.
Copyright, 1895, by Keppler & Schwarzmann.
Entered at N. Y. P. O. as Second-class Mail Matter

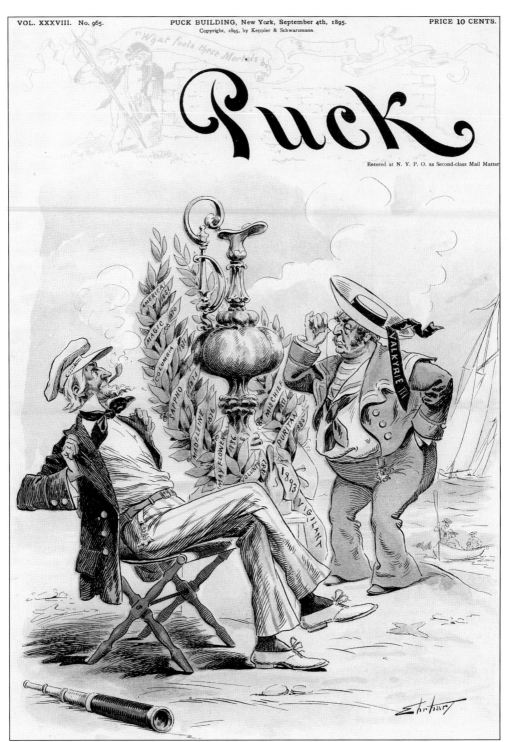

THE COVER OF AN 1895 PUCK SATIRE MAGAZINE. Uncle Sam said to John Bull, "Wa-al old feller, you've got another chance to look at it, anyhow, even if you can't win it!"

IMAGES
of America

THE AMERICA'S CUP
YACHTS
THE RHODE ISLAND CONNECTION

Richard V. Simpson

ARCADIA
PUBLISHING

Published by Arcadia Publishing
Charleston SC, Chicago IL, Portsmouth NH, San Francisco CA

Printed in the United States of America

Library of Congress Catalog Card Number: 9960797

For all general information contact Arcadia Publishing at:
Telephone 843-853-2070
Fax 843-853-0044
E-mail sales@arcadiapublishing.com
For customer service and orders:
Toll-Free 1-888-313-2665

Visit us on the Internet at www.arcadiapublishing.com

Other books by R.V. Simpson:
Crown of Gold: A History of the Italian-Roman Catholic Church in Bristol, RI (1967)
Independence Day: How the Day is Celebrated in Bristol, RI (1989)
Old St. Mary's: Mother Church in Bristol, RI (1994)
Bristol, RI: In the Mount Hope Lands of King Philip (1996)
Bristol, RI, Volume II: The Bristol Renaissance (1998)

Books by R.V. Simpson and N.J. Devin:
Portsmouth, RI: Pocasset: Ancestral Lands of the Narragansett (1997)
Tiverton and Little Compton, RI: Pocasset and Sakonnet, Wampanoag Country (1997)
Tiverton and Little Compton, RI, Volume II (1998)

COVER: The Successful 1980 Cup Defender *Freedom*.

CONTENTS

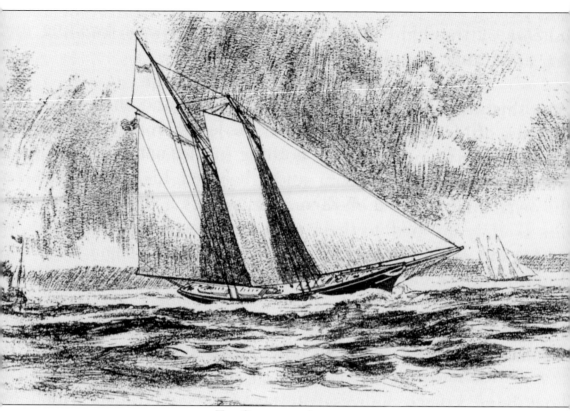

THE SCHOONER AMERICA.

ACKNOWLEDGMENTS

Grateful thanks are extended to Larry Rochette of Sudbury, Massachusetts. Larry is a collector of America's Cup stereo-view cards. He generously allowed me to photograph a large part of his exceptional and prized collection of images.

My sincere appreciation to Phil Growther of Warwick, Rhode Island. Phil is a longtime collector of America's Cup memorabilia, and he is an acknowledged expert on the subject. He generously volunteered to read the entire text for accuracy. He is the archivist for The Museum of Yachting.

INTRODUCTION

On August 22, 1851, the first international yacht race and cup was won by the keel schooner yacht *America*, owned by J.C. Stevens and G.L. Schuyler of New York. The Cup was subsequently offered by its owners to the New York Yacht Club, subject to certain conditions. These conditions, to which others have since been added, are known as the "Deed of Gift." They are the rules under which the Cup is offered in competitive yacht races.

In 1846 two brothers, John C. and Edwin A. Stevens of Hoboken, who about the same time became the most active promoters in the organization of the New York Yacht Club, built the yacht *Maria*, the largest sloop-rigged pleasure craft that had ever been seen afloat up to that time.

When the new boat, *America*, came to be tried with the *Maria*, she was beaten so badly that the syndicate almost relinquished the idea of sending her over to England. After her first trial the *America* was somewhat improved, but she was never able to hold her own against the *Maria*. However, the Stevenses and their associates decided to send her over anyway. The *America's* performance in the Solent is too well known to need retelling.

There were many keel-schooners—the *America*, *Dauntless*, and *Sappho* for example—but prior to 1882 keel-sloops were almost unknown. In that year, several single stickers, built on the model of the English cutters, made their appearance; they failed, however, with one or two exceptions, to win races, and did not secure popularity for the type. The big sloops that won races and, therefore, high places in popular esteem, were the *Fanny*, *Mischief*, and *Gracie*, all beamy, light-draft centerboard yachts.

The *Mischief* was a dangerous adversary in light or moderate weather. She was selected to defend the Cup in 1881 against the Canadian challenger *Atalanta*, and won the races by such a margin that she cast a decidedly farcical aspect to the effort of our neighbors.

In early 1885 the New York Yacht Club commissioned Mr. A. Cary Smith of New York to build a new sloop to meet the challenge of the *Genesta*. The product of the New York syndicate was the *Priscilla*, an enlarged *Mischief*, while that of the Boston syndicate was the *Puritan*, a radical departure from the existing type. The *Puritan* was an embodiment mainly of the ideas of Edward Burgess, a young Bostonian of scientific training who had turned out some fast catboats and other small boats.

The superiority of the *Puritan* under all conditions, and on all points of sailing except running, was conclusively shown in the match. In the first completed race over the

7

regular New York Yacht Club course, she beat the *Genesta* by the decisive margin of 16 minutes, 19 seconds. The second race over an ocean course was not won so easily, but the *Puritan* finished more than two minutes ahead, and won by 1 minute, 38 seconds, corrected time.

Soon after the *Mayflower* triumphed in the 1886 match with the *Galatea*, the New York Yacht Club received notice from the Royal Clyde Yacht Club of a challenge for the succeeding year, and for the first time since 1871, a yacht was built in England for the specific purpose of capturing the America's Cup. This vessel was the *Thistle*. As soon as the dimensions of the *Thistle* were received, General Paine and Mr. Burgess began construction of a new sloop. For the *Volunteer*, the building material selected was steel. The *Thistle* was also built of steel; previous to this, with the exception of the *Galatea*, all the other challengers had been built of wood.

The *Thistle* was by far the fastest and most handsome boat that had yet come to seek the Cup, but she was not fast enough for the *Volunteer*. The *Volunteer* showed her superiority at the very outset of the first race, which she won over the club course. The second race, sailed over a 40-mile ocean course, was not such a walkover, but the *Volunteer* won by the decisive margin of 11 minutes, 48 3/4 seconds, corrected time.

A new figure in yacht design had arisen and a new type of boat had come into being before the next challenge was received for the Cup. The *Gloriana*, as she was called, was built for E.D. Morgan of New York by the Herreshoffs of Bristol, R.I., a firm that had earned a reputation for building fast steam-yachts but had not achieved anything of note in the building of sailing yachts.

The challenge of the *Valkyrie* for 1893 brought out three new boats, the *Vigilant*, *Colonia*, and *Pilgrim*. The first two were built by the Herreshoffs, the last by a Boston firm. The *Vigilant* was a centerboard, the *Colonia* a keel yacht. The struggle for the honor of defending the Cup was confined to these two.

Three races were sailed and the *Vigilant* won the first and second easily, by 5 minutes, 48 seconds, and 10 minutes, 35 seconds, respectively. She also won the third race, though by the narrow margin of 40 seconds. When Lord Dunraven issued another challenge for 1895, Messrs. C.O. Iselin, William K. Vanderbilt, and E.D. Morgan, who had been members of the syndicate which built *Vigilant*, commissioned the Herreshoffs to build them a new boat.

In the *Defender* the Herreshoffs developed the fin keel. She was constructed of both aluminum and bronze. With the *Vigilant*, she showed from the beginning superiority on every point of sailing, and was chosen to meet the newcomer, the *Valkyrie III*.

The first race showed the superiority of the *Defender*, which won by a comfortable margin. In the second encounter, the *Defender*, although crippled immediately before the start by a deliberate foul, sailed a magnificent race. Just before the start of the third race, the *Valkyrie III* withdrew, complaining of interference by the spectator fleet. The *Defender* sailed the course and was declared the winner.

The challenge of Sir Thomas Lipton for 1899 revived the good feeling of true sportsmanship. The Herreshoffs built a fast new boat, the *Columbia*, for Mr. Iselin and Commodore J. Pierpont Morgan of the New York Yacht Club. Thus, the new century dawned with a renewed spirit of vitality in the yachting fraternity.

One

THE NEW YORK YACHT CLUB

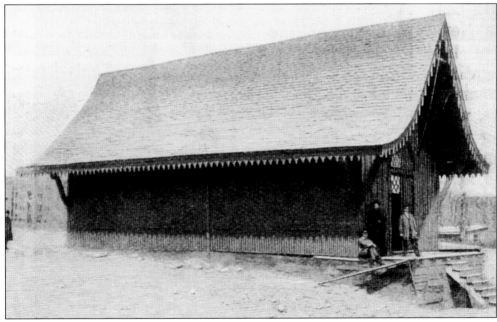

THE NEW YORK YACHT CLUB'S (NYYC) FIRST CLUBHOUSE, C. 1899. Located in the Elysian Fields, Hoboken, on a tract of land owned by the Stevens family, this unpretentious structure was built of wood. It was subsequently occupied by the New Jersey Yacht Club. On July 30, 1844, a number of yachtsmen, realizing the need for an American yachting organization, met in the cabin of John C. Stevens's schooner *Gimcrack*, anchored off the Battery, and founded the New York Yacht Club. The founders were men of action who had met with a definite object in view. At their first session they organized the club, elected Mr. Stevens commodore, and resolved to sail on their first cruise, their destination—Newport. (*Munsey's Magazine* photo.)

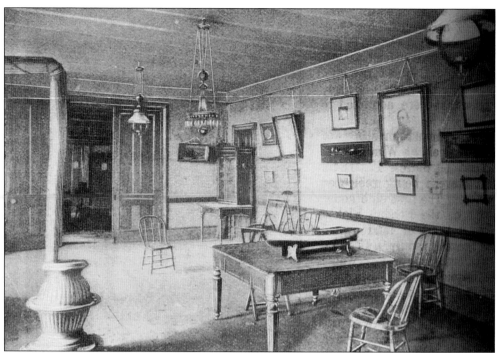

THE INTERIOR OF THE NEW YORK YACHT CLUB'S HOBOKEN CLUBHOUSE. A small room at the back served as the boathouse and dry dock. The yachts of 1844 would provoke a smile today, but no better amateur sailors ever manned a halyard or "tailed on" to the end of a mainsheet than the founders of the NYYC. Under the guidance of these gentlemen sailors, their sport throve and naval architecture was stimulated. (*Munsey's Magazine* photo.)

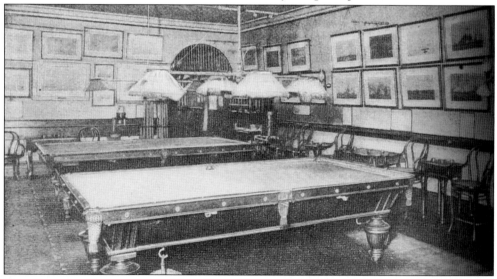

THE BILLIARD ROOM OF THE NEW YORK YACHT CLUB AT 67 MADISON AVENUE. The schooner *America* was designed and built by George Steers for Commodore Stevens and others. The only craft that could beat her in her trial races, preliminary to her voyage to England in 1851, was Stevens's own *Maria*, which used to sail round her with ridiculous ease. (*Munsey's Magazine* photo.)

THE RECEPTION ROOM AT 67 MADISON AVENUE. Over the mantel is a portrait of John C. Stevens, the club's founder and first commodore. Stevens eventually sold the *America* to M. deBlaquiere, who cut down her rig and used her chiefly for cruising in British waters. In 1861 her name was changed to *Camilla*. She was next purchased by a Confederate sympathizer, who fitted her as a cruiser armed with one big gun. Her speed diminished, and her owner, finding her useless as a blockade runner, sailed her up the St. John's River in Florida, where, without ceremony, he sank her. (*Munsey's Magazine* photo.)

THE MODEL ROOM OF THE MADISON AVENUE CLUBHOUSE. These half-models give testament of American progress in yacht design. (*Munsey's Magazine* photo.)

IN THE WAKE OF THE RACES OFF SCOTLAND LIGHTSHIP. It was from the anchorage in the Hudson River opposite the first clubhouse that the start of the first regatta took place on July 17, 1845. Being an almost unknown sport, the races drew thousands of spectators to the banks of the river. The course was from off the clubhouse to the Southwest Spit and back. Nine yachts started, and the fee of $5 went to the purchase of a silver cup for the winner. The eventual winner of the trophy was the owner of the *Cygnet*. This regatta was the precursor of many historic struggles on the water for modest prizes and true love of the sport. (*Munsey's Magazine* photo.)

THE LIBRARY OF THE MADISON AVENUE CLUBHOUSE. The library is a treasure room of literature on the sport of yachting. (*Munsey's Magazine* photo.)

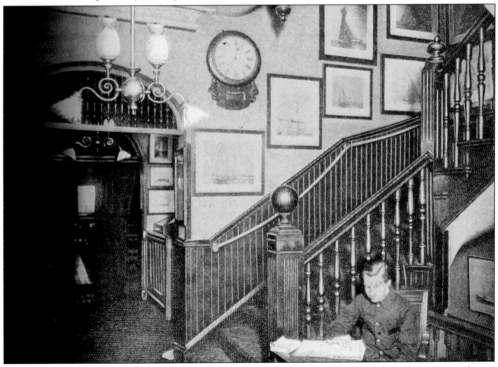

THE ENTRANCE HALL OF THE MADISON AVENUE CLUBHOUSE. Though a magnificent mansion, it is not as elegant as the new building on West Forty-Fourth Street. (*Munsey's Magazine* photo.)

THE NEW YORK YACHT CLUB'S SECOND WATERFRONT CLUBHOUSE. This building was located on Staten Island, near Fort Wadsworth. (*Munsey's Magazine* photo.)

A Rendezvous of the New York Yacht Club Fleet, c. 1895. This gathering at Glen Cove, Long Island, took place shortly before the annual cruise to Newport. The black steam yacht on the left is Mr. Pierpont Morgan's *Corsair*, later the USS *Gloucester*. (*Munsey's Magazine* photo.)

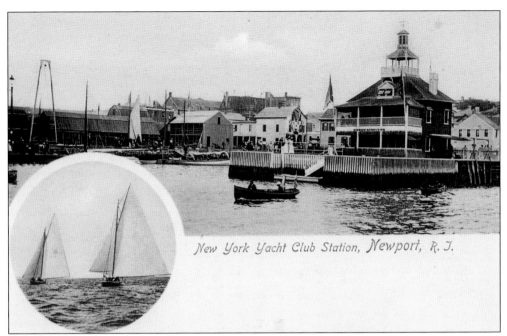

NEWPORT STATION OF THE NEW YORK YACHT CLUB, C. 1903. When the little squadron of sloops and schooners of the newly founded New York Yacht Club arrived at Newport on August 5, 1844, they were greeted by but a few curious sailors and dock-hands. Newport was then only an old-fashioned fishing town, with quaint streets, quainter inhabitants, and 18th-century buildings.

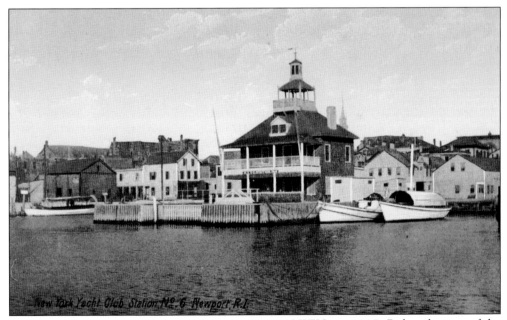

A WATER VIEW OF THE NEWPORT STATION OF THE NYYC, C. 1907. Before the turn of the century, no palaces crowned Newport's picturesque heights; millionaires had yet to discover its many charms. The advent of the squadron was nevertheless an important epoch in Newport's history. The city owes much of its present prosperity to yachtsmen.

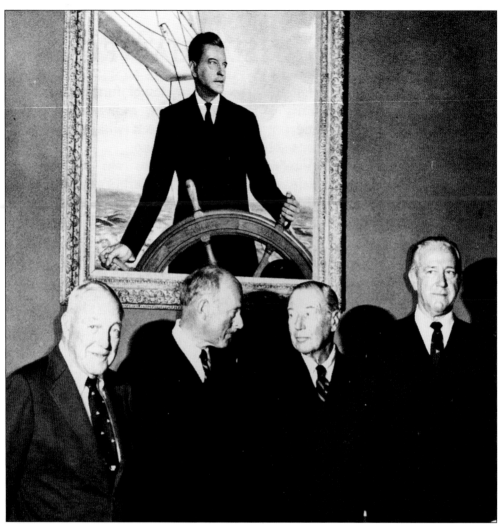

A MEETING IN THE HAROLD S. VANDERBILT MEMORIAL ROOM AT HIS NEWPORT MARBLE HOUSE, C. 1980. Past commodores of the New York Yacht Club, from left to right, include George R. Himman, Henry H. Anderson Jr., Donald B. Kipp, and Robert W. McCullough, who was also chairman of The America's Cup Committee. They are standing underneath a painting of Mr. Vanderbilt at the wheel of the *Ranger*. Mr. Vanderbilt successfully defended the America's Cup three times—in 1930 with the *Enterprise*, in 1934 with the *Rainbow*, and in 1937 with the *Ranger*. (Courtesy of The Preservation Society of Newport.)

NEWPORT HARBOR AT THE TURN OF THE CENTURY, DURING THE GOELET CUP DEFENDER TRIAL RACES. Even though the early races were held off Sandy Hook, New Jersey, the trial races were sailed in Rhode Island waters, and Newport played host. (Rochette photo.)

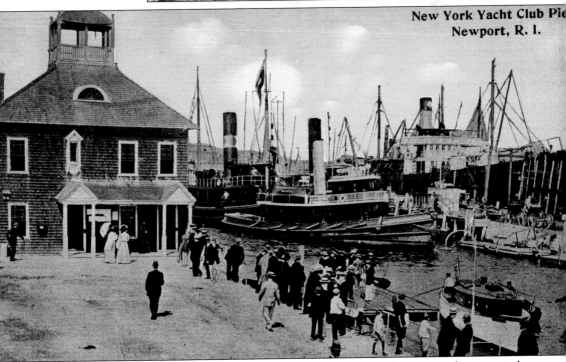

New York Yacht Club Pie
Newport, R. I.

NEWPORT PIER OF THE NYYC, C. 1910. Much of Newport's present fame as a yachting capital is due to a former NYYC commodore, James Gordon Bennett, who was one of the first young men of wealth to realize Newport's advantages as a harbor and its charms as a summer colony. Bennett was a pioneer of Newport's summer "cottage" building frenzy.

17

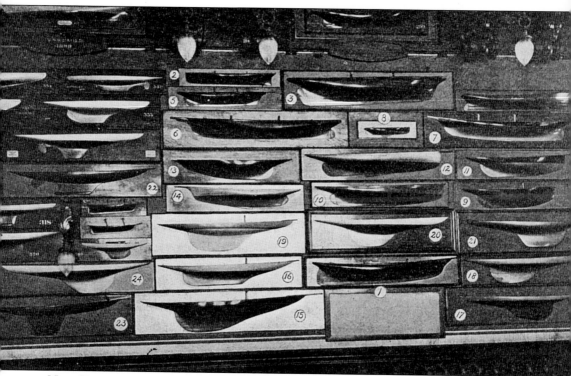

New York Yacht Club's Collection of America's Cup Yacht Models, c. 1903.
The April 11, 1903 edition of *Scientific American* published this photo with considerable text devoted to the NYYC collection of half-models. At that time, the weekly journal reported some 500 half-models were owned by the club.

In this photo, both defender's and challenger's profiles are represented. They are as follows: 1. the *America*; 2. the *Magic*; 3. the *Cambria*; 4. the *Madeleine*; 5. the *Livonia*; 6. the *Columbia*; 7. the *Sappho*; 8. the *Mischief*; 9. the *Genesta*; 10. the *Puritan*; 11. the *Galatea*; 12. the *Mayflower*; 13. the *Thistle*; 14. the *Volunteer*; 15. the *Valkyrie II*; 16. the *Vigilant*; 17. the *Valkyrie III*; 18. the *Defender*; 19. the *Shamrock*; 20. the *Columbia*; 21. the *Shamrock II*; 22. the *Jubilee*; 23. the *Pilgrim*; and 24. the *Constitution*.

In the frame directly below the *America* model is the original drawing of the yacht's lines from which she was built, truly a rare sheet of paper. The historic *America* was a fore-and-aft schooner, 80 feet on the waterline, 94 over all, and 22.5 abeam, drawing 11.5 feet. (*Scientific American* photo.)

HAROLD S. VANDERBILT'S RANGER. In 1936 the NYYC received another Sopworth challenge. Because the ongoing Depression made itself felt even in the plush parlors of well-to-do American yachtsmen, NYYC members were not forthcoming to join Vanderbilt's new syndicate. If the Cup was to be defended properly, a new J-boat of superior design needed to be built. Vanderbilt shouldered the entire cost of design and construction of his new defender. He engaged Starling Burgess and Olin J. Stephens Jr. to design the *Ranger*; she was built in Bath, Maine.

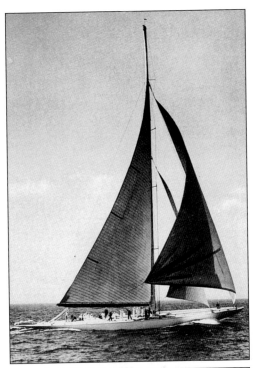

THE *ATLANTA* AND THE **NYYC** COMMITTEE BOAT AT THE **1885** MATCH. The *Atlanta* was built for Jay Gould in 1883. She was 249 feet long, weighed 568 tons, had a 1,000-horsepower engine, and employed a crew of 52. (Rochette photo.)

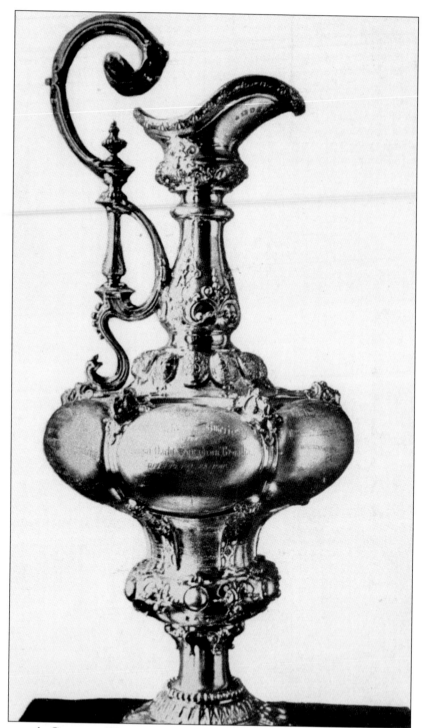

THE AMERICA'S CUP, THE WORLD'S MOST PRESTIGIOUS SPORTS TROPHY. Originally called the "One Hundred Guinea Cup," no single memorial of victory ever crafted by the silversmith's hand is better known than the America's Cup. It stands 27 inches high, weighs 135 ounces, and was made in the gaudy high-Victorian style by R. & S. Garrard, England.

Two

NINETEENTH-CENTURY RACES

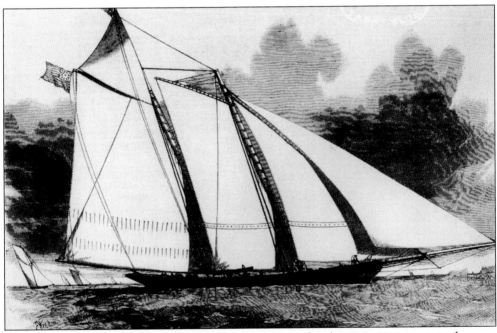

THE SCHOONER YACHT AMERICA. The *America* was completed in time to compete in the races held at the Great International Exhibition (World's Fair), organized by Prince Albert in 1851. She handily defeated 14 other vessels in the Royal Yacht Squadron race around the Isle of Wight. The prize was a new 100-guinea cup. In 1857, the owners of the *America* deeded the cup to the New York Yacht Club with the condition that the club place it forever in international competition.

THE FIRST PERIOD—SCHOONER TO SLOOP. Pictured, from left to right, are the following ships and the years they competed: the *Columbia* (1871); the *Madeleine* (1876); the *America* (1851); the *Mischief* (1881); and the *Magic* (1870). (*Scientific American* photo.)

THE SECOND PERIOD—SLOOP TO CUTTER-SLOOP. Pictured, from left to right, are the following ships and the years they competed: the *Vigilant* (1893); the *Puritan* (1885); the *Columbia* (1899 and 1901); the *Defender* (1895); the *Mayflower* (1886); and the *Volunteer* (1887). (*Scientific American* photo.)

THE MAGIC, 1870. The first challenge for the America's Cup came in 1870 from the Royal Thames Yacht Club in England with James Ashbury's schooner *Cambria*. She was met by 23 American schooners, one of which was the original *America*. The NYYC schooner *Magic*, owned by J.F. Osgood, beat her by a good half hour in two races, each about 35 miles long.

THE COLUMBIA, 1871.
The challenge came from the Royal Harwich Yacht club with James Ashbury's schooner *Livonia*. This time the defenders had four vessels to meet him. The *Columbia* won the first two races but was disabled in the third, losing to *Livonia*. The Americans substituted the *Sappho*, which won the next two races and declared the match over, having won four out of a possible seven. Ashbury threatened legal proceedings. His protests had some effect, however, since challengers were never again forced to meet more than one defending yacht.

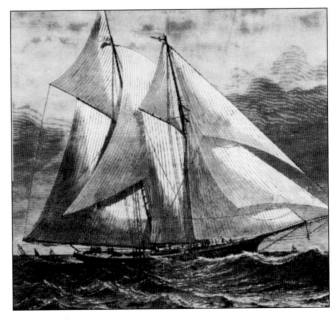

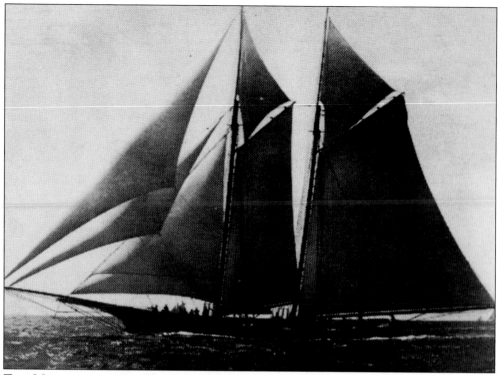

THE MADELEINE, 1876. The Royal Canadian Yacht Club challenged with the schooner Countess of Dufferin from the Great Lakes. The Madeleine easily defeated her in the two-race series. Race 1 was a 32.6-mile triangular course. Race 2 was a windward-leeward course totaling 40 miles in which spinnakers were used for the first time in an America's Cup Race. This was the last Cup series sailed in schooners. They ranged in length from 84 to 140 feet.

The Mischief, 1881. The first NYYC yacht to be chosen as Cup defender after a series of trials, the Mischief met the Canadian challenger, the sloop Atalanta from the Bay of Quinte Yacht Club. The defender easily won the two 32-mile races.

THE *PURITAN*, 1885.
This year the challenge came from England. Sir Richard Sutton, Royal Yacht Squadron, arrived with his yacht *Genesta*. The race embraced the usual 32.6-mile triangular and the 40-mile windward-leeward courses. Both races were won by the New York Yacht club's *Puritan*.

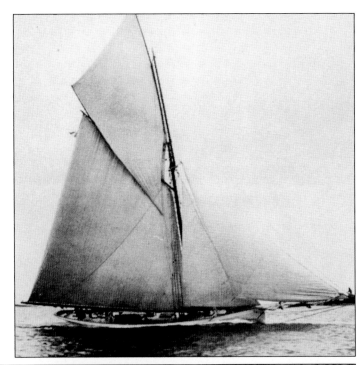

THE ENGLISH CHALLENGER *GENESTA*, IN A RACE WITH THE NYYC DEFENDER *PURITAN*, **1885.** The *Genesta* is beating to the home mark in a 37-knot wind. The second race, over an ocean course from the Scotland Lightship 20 miles leeward, was sailed in a strong breeze from the start and a gale toward the close, and was not won easily. Better handling, rather than parity in the qualities of the yachts, accounted for the good showing of the Englishman.

THE MAYFLOWER RUNNING HOME, 1886. In several important respects, General Charles J. Paine's *Mayflower* differed essentially from the *Puritan*. She had greater water-line length, less proportional beam, more draft, more ballast, and a larger sail area.

Lieutenant Richard Henn of the Royal Northern Yacht Club challenged in 1885, but it wasn't until 1886 that the match took place. The new British yacht, the *Galatea*, did not differ essentially from the *Genesta* except in size; although a leaner vessel, her lines were not as fine.

In the first race, over the regular club course, with a light wind, the *Mayflower* won by 12 minutes, 2 seconds, corrected time. In the second and final race, with a light breeze over a 40-mile ocean course, the *Mayflower* won by 29 minutes, 9 seconds, corrected time. (*Leslie's Monthly Magazine* illustration.)

THE *VOLUNTEER*. In 1887 the Royal Clyde Yacht Club challenged for the Cup. The Scottish cutter *Thistle* was so fast that the British were sure of bringing home the Cup this time. The Scots arrived with their challenger in good spirits, complete with bagpipes. As soon as the dimensions of the *Thistle* were received, General Paine and Mr. Burgess began construction of a new sloop, the *Volunteer*. Not even the *Mayflower* could approach her in speed on their first round of trials, and she won every race she entered during the entire season. The *Volunteer* won the first Cup race by 19 minutes, 23 3/4 seconds, and the second by 11 minutes, 48 3/4 seconds, corrected time. (*Boston Sunday Journal*, September 24, 1899.)

THE *VIGILANT* AND *VALKYRIE II* AT THE START OF THE FINAL RACE OF THE EIGHTH CHALLENGE, OCTOBER 13, 1893. The *Vigilant* was a centerboard vessel built of Tobin bronze for strength and lightness. In the defender trials, she showed herself to be the better all-round boat and was named as the defender. The *Valkyrie II* was nearly 9 inches shorter on the water-line than the *Vigilant*, and she had 1,230 square feet less sail spread

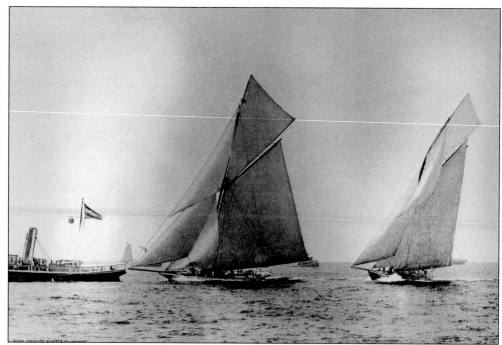

LORD DUNRAVEN CHALLENGED AGAIN IN 1895 WITH THE VALKYRIE III. The yacht *Defender* won the first race, and in the second, the *Valkyrie III* fouled her and was disqualified. This photo of the second race, on September 10, 1895, captures the *Defender* (right) struggling onward with a sagging topmast shroud just 5 seconds after the foul by the *Valkyrie III*.

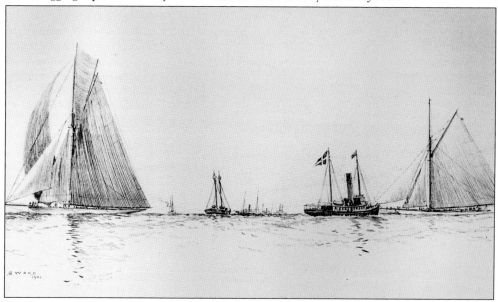

THE *DEFENDER* ALONE IN THE FINAL RACE OF THE NINTH CHALLENGE CONTEST, SEPTEMBER 12, 1895. Just before the start of the third race, the *Valkyrie III* withdrew, complaining to the committee of interference by the spectator fleet. The *Defender* sailed the course and was declared the winner. It was after this race that Lord Dunraven was expelled as an honorary member of the NYYC.

LAYING THE MARK FOR THE 1895 RACES. (Rochette photo.)

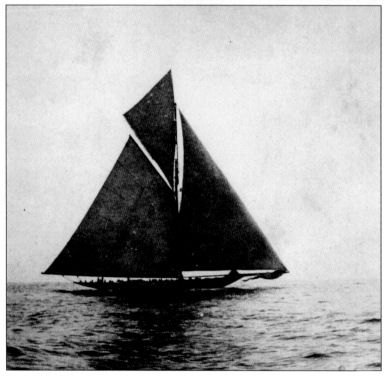

THE VALKYRIE III, 1895. The committee had little control of the spectator fleet and was powerless to keep them at a distance. Their judgment was that the crowding had no more affect on the challenger than on the defender. (Rochette photo.)

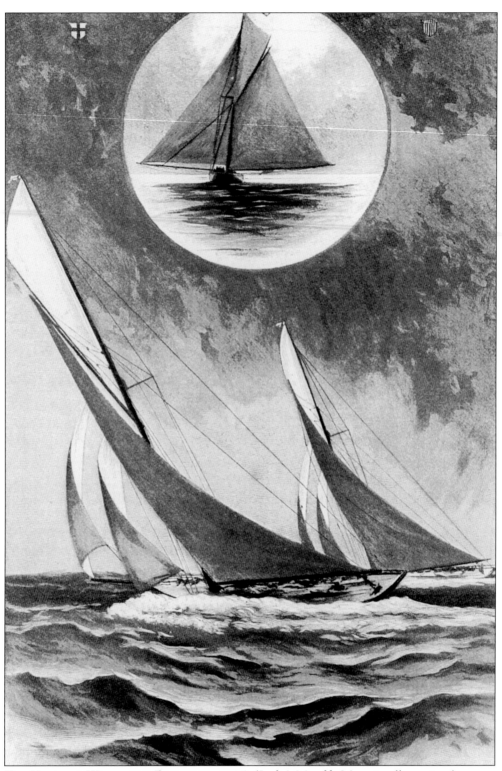

THE VALKYRIE III AND THE DEFENDER, 1895. (*Leslie's Monthly Magazine* illustration.)

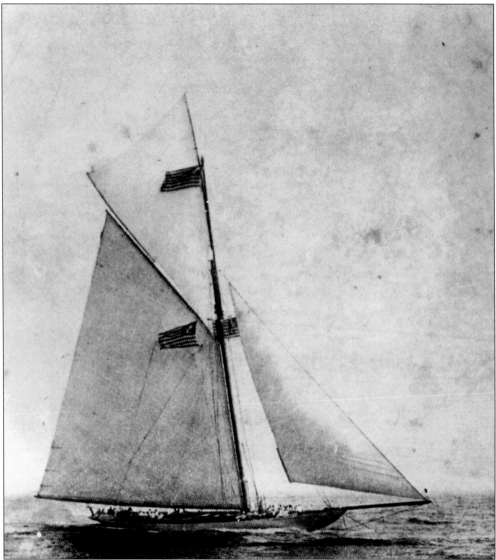

The Victorious *Defender*. In his *An Introduction to Yachting* (Sheridan House, 1963), L. Francis Herreshoff writes: "The press handled Lord Dunraven rather unmercifully but it must be remembered that this country had not then become of age diplomatically so the ridiculous controversies about the challenger's several protests were kept up during the next winter. It is my opinion that Lord Dunraven saw in the first race that *Defender* was a much faster boat than *Valkyrie III* and he was so sorely disappointed and mentally upset that he was not responsible for his actions. . ." (Rochette photo.)

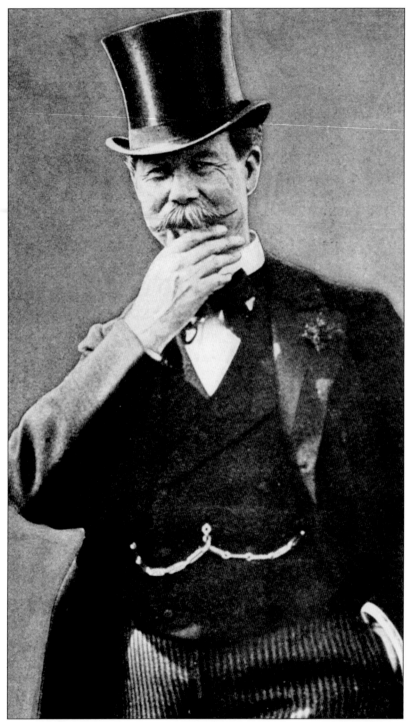

THE BRITISH TEA MERCHANT GREATLY ADMIRED BY AMERICAN YACHTSMEN. In 1899, when a challenge came from the Royal Ulster Yacht Club, Sir Thomas Lipton appeared on the scene. He was determined to win the Cup for England; he spared no expense and mounted five heroic campaigns against the American defenders.

Three

Sir Thomas Lipton
and the
Shamrock Challenges

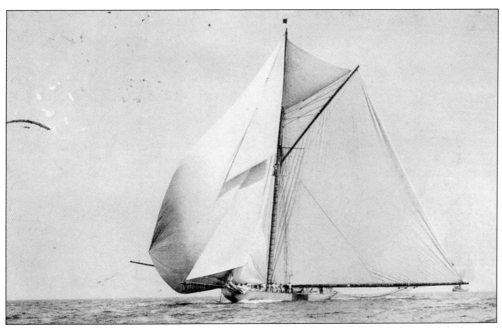

THE 1899 CHALLENGE OF SIR THOMAS LIPTON. This challenge revived the good feelings of the NYYC toward the British. Lipton's 129-foot sloop *Shamrock* was designed by Fife, who had turned out some of the fastest yachts in English waters. No less eager to win the Cup was J. Pierpont Morgan, who commissioned Nathaniel Herreshoff to design and build the *Columbia*.

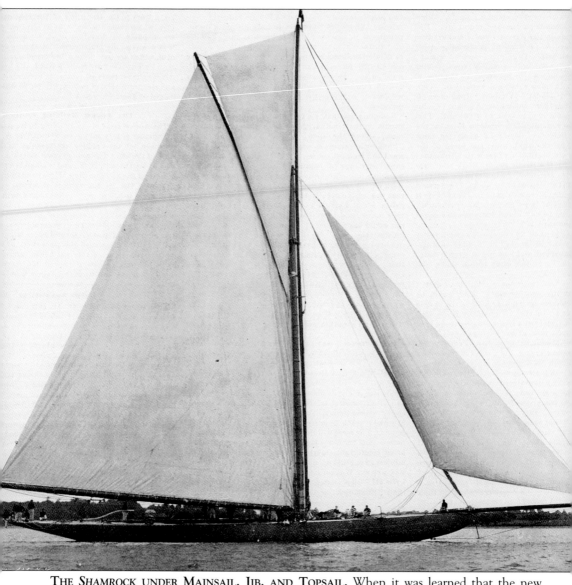

THE SHAMROCK UNDER MAINSAIL, JIB, AND TOPSAIL. When it was learned that the new champion for the America's Cup was to come from the drawing board of Mr. William Fife Jr., those in the know about such things predicted that matters would be decidedly interesting off Sandy Hook in the early days of October 1899.

The *Shamrock* established a decided superiority in going to windward. On this point of sailing she was certainly superb, at least in the light winds that prevailed. In running she was no faster than the *Columbia*; whenever the two boats were on a reach in the same weight of wind, the *Columbia* more than held her own. (*Scientific American* photo.)

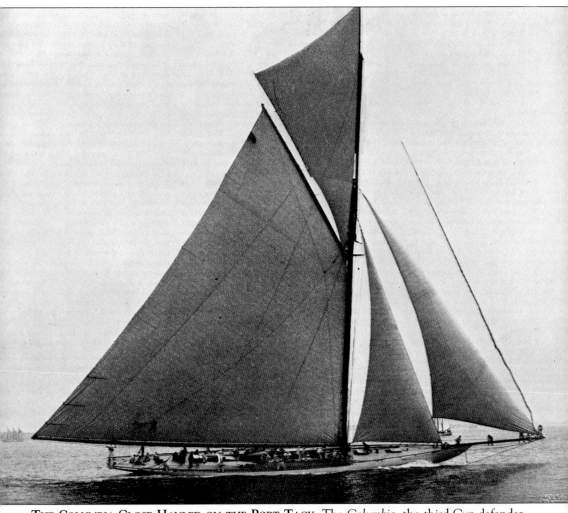

THE COLUMBIA CLOSE-HAULED ON THE PORT TACK. The *Columbia*, the third Cup defender designed by Nat Herreshoff, was another example of the gradually evolving international racing machine. She was made of bronze, was 3 feet longer than the *Shamrock*, and had a deeper, more narrow keel. "Inside her hull were a network of steel beams, braces and emptiness," reported an observer.

The five-race series, planned for early October, didn't begin until October 16. The contestants waited nearly two weeks before a suitable breeze came up. They sailed in light air and had to work their way through heavy fog. Finally, a stronger wind rose and the fog lifted during the final leg. The *Columbia* showed that she could sail better upwind than the *Shamrock* and won by 10 minutes, 8 seconds. (*Scientific American* photo.)

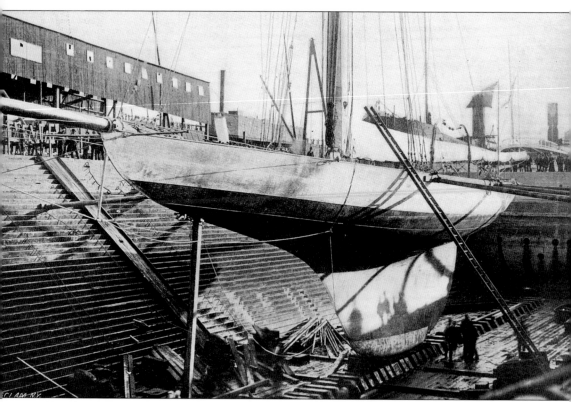

THE *SHAMROCK* AT THE ERIE BASIN, BROOKLYN, OCTOBER 1899. Next to the races themselves, there is no event connected with the contest for the Cup equal in public interest to the docking of the yachts and the consequent disclosure of their underwater form, for it is in the model of the yacht and not in the sail plan that the genius of the designer is most apt to reveal itself.

The characteristics of the typical up-to-date yacht, as represented in a "ninety-footer," are seen here to be typical of both the defender and the challenger—the beam of about 24 feet and a draft of 20 feet; some 80 or 90 tons of lead on the keel; a displacement of from 140 to 150 tons; and a sail area of about 13,000 square feet. The materials of construction include nickel steel for the framing, plating of non-corrosive bronze, and hollow steel spars of great strength and lightness. (*Scientific American* photo.)

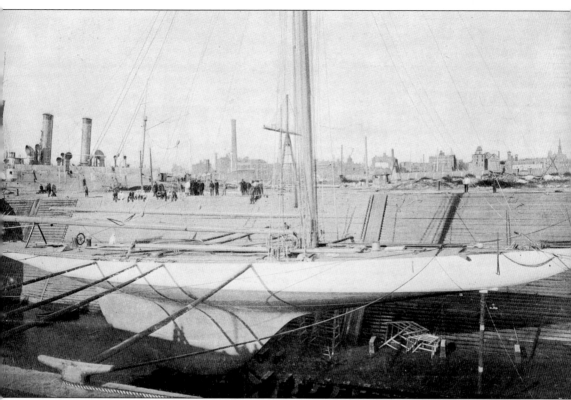

The Columbia at the Brooklyn Navy Yard, October 1899. The *Shamrock* and the *Columbia* conformed very closely to the specifications on the preceding page (at least as far as dimensions and materials are concerned). Both boats, above and below the water line, have very marked differences in design, but in no sense can either be called a surprise. They possess all the characteristics that distinguish a Herreshoff from a Fife design. The *Columbia* is an improved *Defender*, and the Shamrock is an enlarged and improved *Isolde*.

Compared with the 1895 champion, the *Columbia* is in every way a more beautiful yacht. The variations from the *Defender* are all in securing a finer form, one that can be driven through the water with less expenditure of power. While the beam is wider and the lead placed lower, the overhangs and the waterline length are considerably larger, and the entrance and delivery are finer than in the older boat. The hull proper is deeper, and the whole model is a further departure than that of the *Defender* from the old skimming dish type of hull. (*Scientific American* photo.)

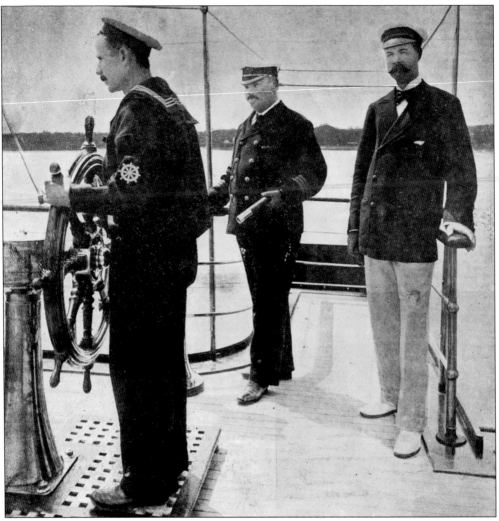

SIR THOMAS JOHNSTONE LIPTON AND CAPTAIN WRINGE ON THE BRIDGE OF LIPTON'S STEAM YACHT, THE *ERIN* (FORMERLY THE *AEGUSA*), C. SEPTEMBER 1899. Lipton purchased the *Erin* at a cost of $375,000, for the purpose of convoying the *Shamrock* to America for its challenge, according to the *Boston Sunday Journal* of September 24, 1899.

Although a member of the Royal Ulster Yacht Club, Sir Thomas was not a yachtsman. His challenge, it was widely reported, was due wholly to his determination of keeping the name of Lipton before the world.

MANEUVERING FOR THE START FROM THE SANDY HOOK LIGHTSHIP, 1899. A five-race series was planned, and the first race was run on October 16. The antagonists sailed through heavy fog and light breezes; eventually a stronger wind rose and the fog lifted. (*Scientific American* photo.)

NEARING THE LINE, THE COLUMBIA AHEAD, THE SHAMROCK LOWERING HER SPINNAKER POLE TO STARBOARD. During the final leg, the *Columbia* showed herself to sail better upwind than the *Shamrock* and won by 10 minutes, 8 seconds. (*Scientific American* photo.)

CROSSING THE LINE. The *Columbia*, 17 seconds in the lead, sets her balloon jib topsail, and the *Shamrock* luffs up into the weather position. During the second race, the boats were pounded by heavy gusts, one of which snapped the *Shamrock's* topmast and carried away her topsail. Skipper Archie Hogarth put her into the wind to try to jury-rig the damage, but it was beyond repair. The challenger retired from the race, giving the *Columbia* her second win. (*Scientific American* photo.)

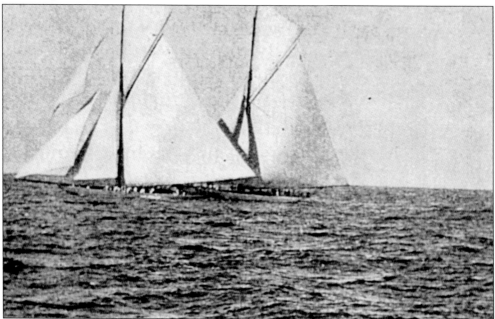

ROUNDING THE MARK, THE SHAMROCK NINE SECONDS IN THE LEAD. The *Columbia* establishes an overlap and rounds between the *Shamrock* and the mark. In the third race the *Shamrock* soared along at 13 knots in a strong northerly wind. However, the *Columbia* was faster; she won by 6 minutes, 34 seconds. (*Scientific American* photo.)

THE COLUMBIA PASSING THE COMMITTEE BOAT. The *Boston Sunday Journal* of September 24, 1899, reports: "Another matter of interest is that while the *Columbia* is so nearly like the *Defender* that only the expert eye can find the points of improvement in the former when the two are side by side . . ." (*Boston Sunday Journal* photo.)

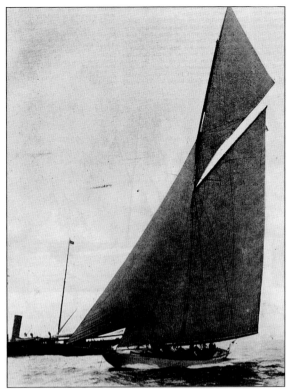

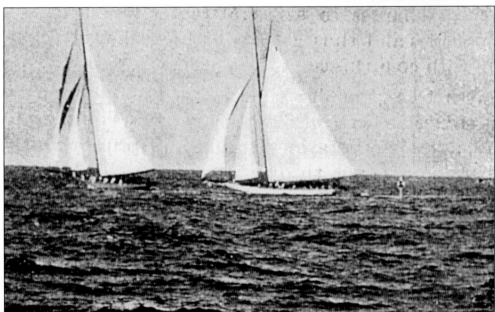

THE MARK ROUNDED AND THE YACHTS CLOSE-HAULED ON THE STARBOARD TACK. A contemporary review of the races reported: "The only point of sailing on which *Shamrock* established superiority was in going to windward, at least in light winds. In running she is no faster than *Columbia*; and whenever the two boats have been on a reach in the same weight of wind, *Columbia* has more than held her own." (*Scientific American* photo.)

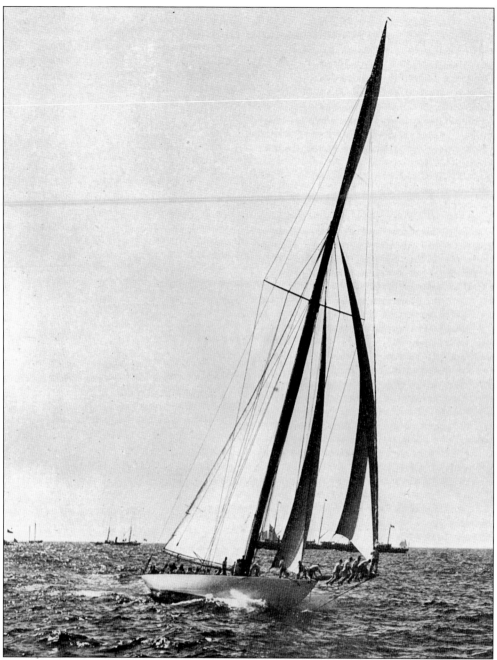

PREPARING FOR THE RACE, 1901. The *Columbia*, designed and built by the Herreshoff Manufacturing Co., sets her jib topsail in the 12th defense of the America's Cup. In 1901, after many trials against the *Constitution* and the *Independence*, she was again chosen to defend the Cup against the *Shamrock II*. (*Leslie's Weekly* photo.)

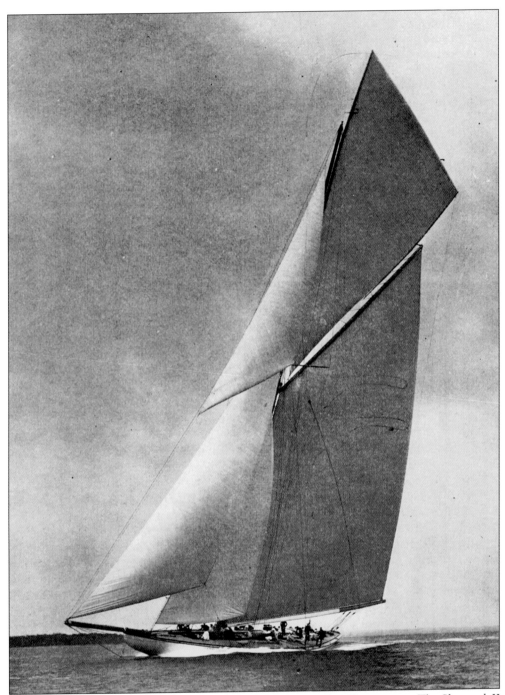

SIR THOMAS LIPTON'S SHAMROCK II PREPARING FOR THE 1901 CHALLENGE. The *Shamrock II* is an overall length of 135 feet, 25 feet abeam, with a 19-foot draft; she carries 95 tons of ballast and 14,200 feet of sail. British experts announced: ". . . she is undoubtedly the most beautifully lined challenger that has ever been built, and, though there is a possibility that she may sail a little tender in fresh winds, the hull carries with it the suggestion that she will be a dangerous opponent in anything less than moderate winds." (*Scientific American* photo.)

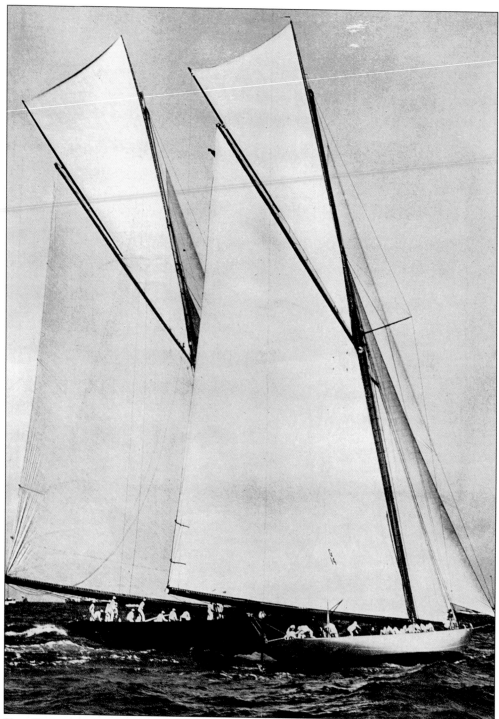

THE COLUMBIA (FOREGROUND) AND THE SHAMROCK II, 1901. The yachts, shown just before the 5-minute gun, are seen jockeying for the best position. The *Shamrock II* was considered to be a considerable foe to challenge for the Cup held by the New York Yacht Club for 50 years. (*Leslie's Weekly* photo.)

Two Minutes before the Beginning of the First Race, 1901. The *Columbia* is the boat with the light-colored hull. (*Leslie's Weekly* photo.)

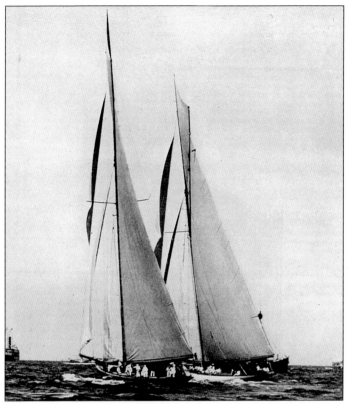

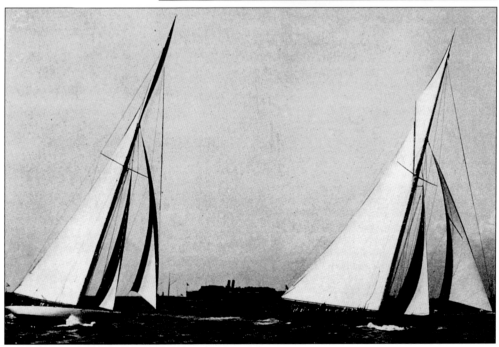

Contenders Spar and Jockey as They Approach the Stake Boat, Seconds before the Starting Gun. (*Leslie's Weekly* photo.)

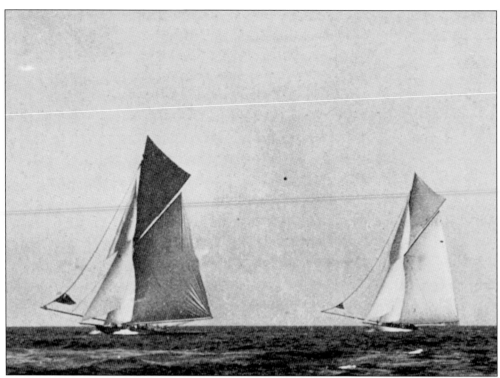

GALLANT CONTENDERS RUNNING NEARLY NECK AND NECK. Just after rounding the mark, the *Columbia* (right) pretends to break out her spinnaker. The *Shamrock II*, about to do the same, discovers that it has been caught napping and recalls the order. (*Leslie's Weekly* photo.)

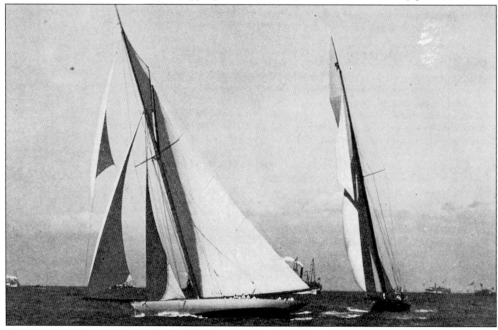

END OF THE RACE, 1901. Seconds before crossing the line, the *Columbia* is in the favored position. (*Leslie's Weekly* photo.)

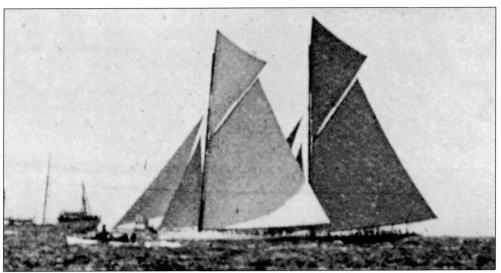

CROSSING THE LINE AT THE GUN, 1901. The *Columbia* to windward leaves the *Shamrock II*. (*Leslie's Weekly* photo.)

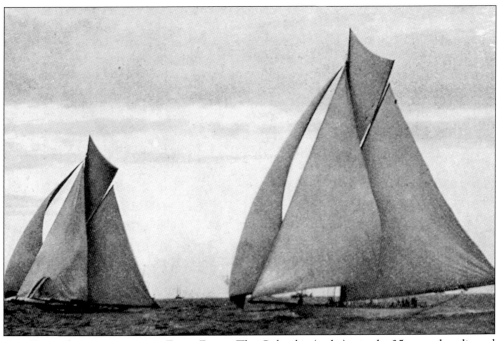

THE FINAL STRUGGLE OF THE FIRST RACE. The *Columbia* (right) wins by 35 seconds, adjusted time 1 minute, 20 seconds. (*Leslie's Weekly* photo.)

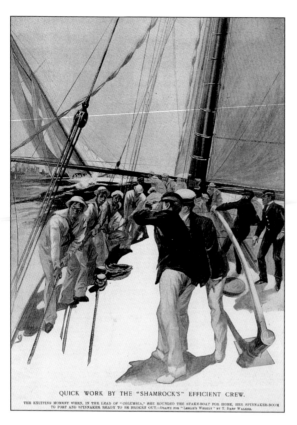

QUICK WORK BY THE SHAMROCK II'S EFFICIENT CREW. This is an illustration for *Leslie's Weekly* by T. Dart Walker. It was the exciting moment when, while leading the *Columbia*, the *Shamrock II* rounded the mark boat for home, her spinnaker-boom to port and her spinnaker ready to be broken out. (*Leslie's Weekly* photo.)

QUICK WORK BY THE "SHAMROCK'S" EFFICIENT CREW.

THE EXCITING MOMENT WHEN, IN THE LEAD OF "COLUMBIA," SHE ROUNDED THE STAKE-BOAT FOR HOME, HER SPINNAKER-BOOM TO PORT AND SPINNAKER READY TO BE BROKEN OUT.—DRAWN FOR "LESLIE'S WEEKLY" BY T. DART WALKER.

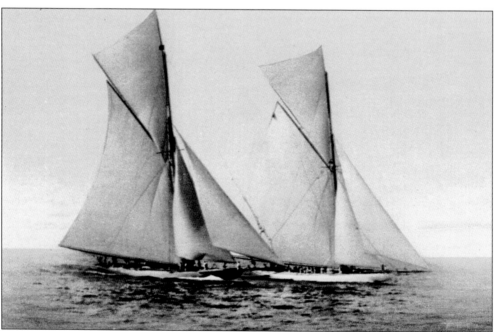

A STUDY OF TWO ELEGANT FLYERS. The *Shamrock II* (foreground) and the *Columbia* are shown here during a thrilling moment in the first match of the eleventh challenge. (*Leslie's Weekly* Photo.)

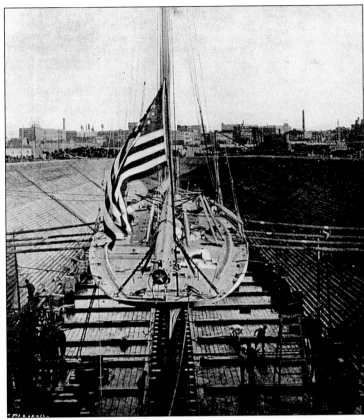

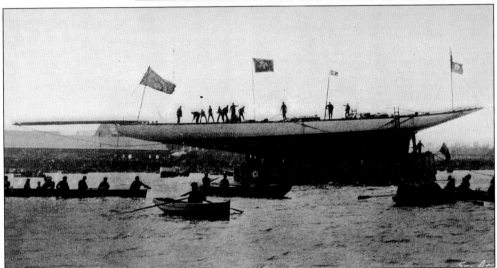

THE SHAMROCK II AFLOAT IN HER LAUNCHING PONTOONS. The shallowness of the water on the Leven made it impossible to launch the boat in the usual way, so large pontoons were built on each side of the yacht for the purpose of floating her over the shallows. The pontoons, incidentally, had the effect of concealing a large part of her underbelly when she went down the ways. Supported on these, she was floated at 10 feet above her normal waterline, and she was taken out of the Leven and taken to Glasgow with little difficulty. (*Scientific American* photo.)

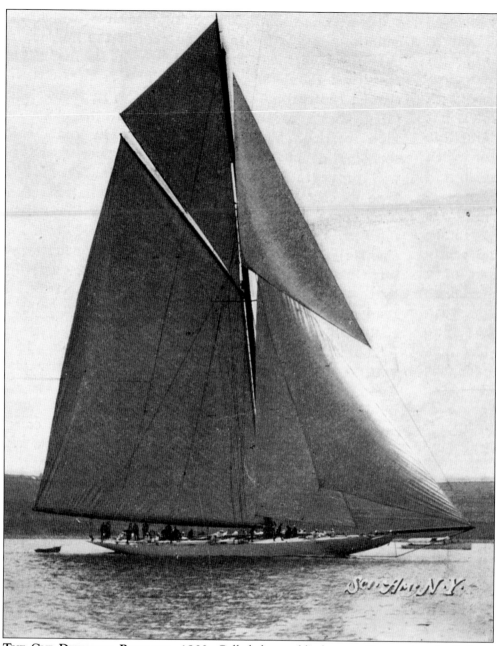

THE CUP DEFENDER RELIANCE, 1903. Called the world's fastest sailing yacht, the *Reliance* shows her enormous sail spread. Herreshoff designed and built the 143-foot-long *Reliance*. Both the *Shamrock III* and the *Reliance* were giant sloops with long overhangs at the bow and stern, wide beams, and shallow draft hulls with deep heavy fin keels. (*Scientific American* photo.)

THE RELIANCE ENTERTAINING THE INSPECTION COMMITTEE. The new defender's massive dimensions dwarfed those of the *Shamrock III.* The *Reliance's* boom was 114 feet in length, her distance from forward side of mast to end of bowsprit was over 80 feet, and her height from deck to truck was over 150 feet. On her spars the *Reliance* spread a total area of canvas just short of 16,000 square feet. (*Scientific American* photo.)

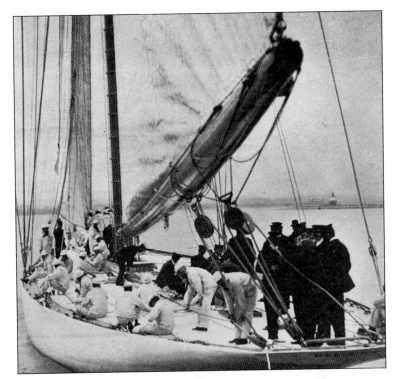

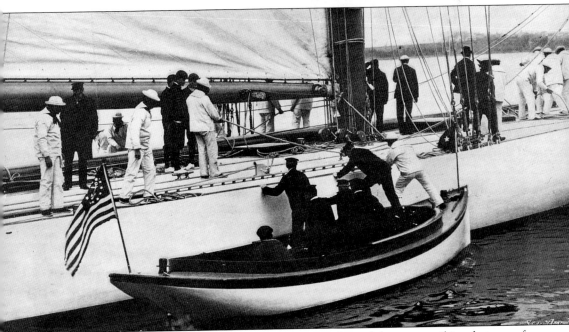

THE INSPECTION COMMITTEE BOARDS THE RELIANCE. One of the most striking features of the *Reliance* is her long drawn-out bow, which projects nearly 30 feet beyond the waterline. Many seasoned yachtsmen wondered aloud why the bow was not made shorter relatively to the stern; for in a low, long stern, such as that of the *Reliance*, every foot of length can be utilized. (*Scientific American* photo.)

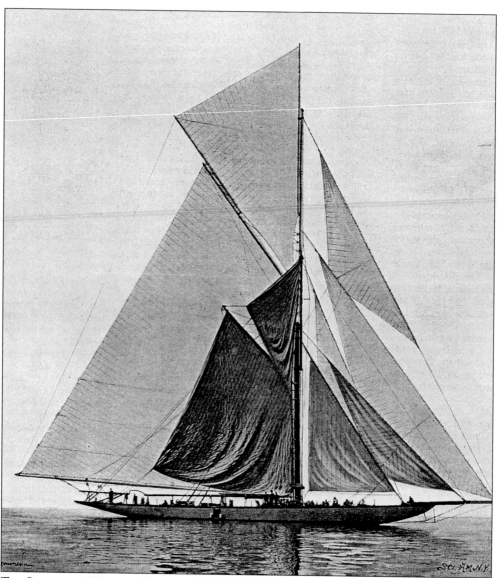

THE *SHAMROCK III* IN HER CRUISING OCEAN AND RACING RIGS (COMPOSITE ILLUSTRATION).
Lipton's new boat carried a total area of sail of about 14,500 square feet. Her main boom was
said to be 105 feet in length, which is a little over 2 feet more than the length of the boom on
the *Shamrock II*. The distance from the forward side of the mast to the end of the bowsprit is 78
feet, which is the same as on the *Shamrock II*. The height from deck to cap is 145 feet. (*Scientific
American* photo.)

A Stern View of the Shamrock III Showing her Broad and Powerful Quarters. Her overall length is close to 140 feet, her waterline length is slightly under 90 feet, her beam about 25.5 feet, and her draft in racing trim is 21 feet. Her displacement is in the neighborhood of 150 tons. (*Scientific American* photo.)

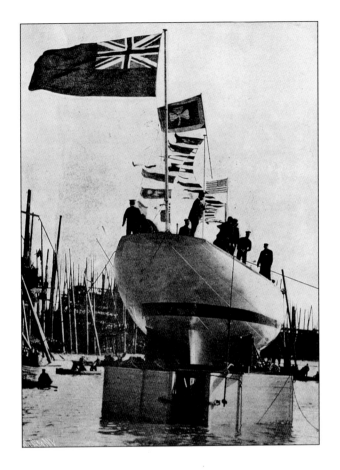

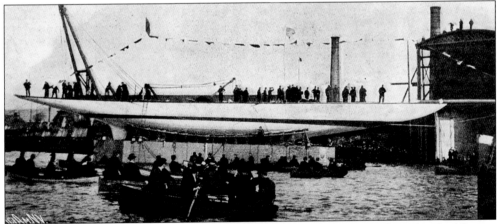

The Shamrock III on her Launching Pontoons. In measurement alone the third Lipton challenger stands out as distinct from any of its predecessors. With the possible exception of the *Valkyrie III*, previous challengers had followed a distinct line of development. The progress from one to the other is easily traced, and the efforts made in each succeeding boat to make good the apparent weaknesses in her predecessors were easily distinguishable. (*Scientific American* photo.)

SIR THOMAS LIPTON ABOARD HIS STEAM YACHT, THE *ERIN*. The *Erin* was built by John Scott & Company of Greenock and was rated at 16 knots. She was said to be "the most luxurious imaginable." (Rochette photo.)

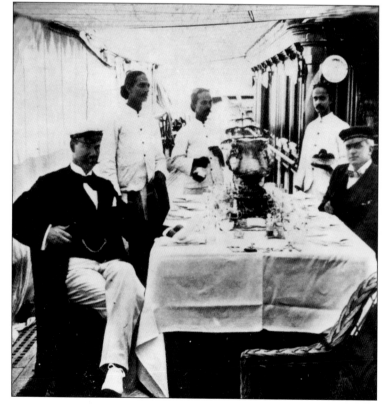

SIR THOMAS AND HONORABLE MR. RUSSELL ABOARD THE *ERIN*. The men are awaiting the arrival of luncheon guests. The prominently displayed massive gold Cup was presented to Sir Thomas by American admirers. (Rochette photo.)

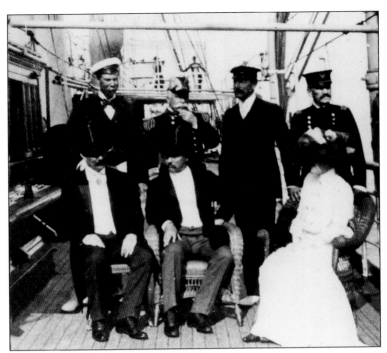

SIR THOMAS (STANDING, LEFT) WITH THE PRESIDENT AND MRS. ROOSEVELT, AUGUST 17, 1903. The President and other dignitaries enjoy an afternoon aboard the President's steam yacht *Mayflower*. (Rochette photo.)

SIR THOMAS AMONG HIS GUESTS ABOARD THE *ERIN* AS THEY RETURN FROM THE DAY'S RACE, SEPTEMBER 28, 1901. The unsmiling faces betray the *Shamrock II*'s loss to the *Columbia* by 1 minute, 20 seconds, corrected time. (Rochette photo.)

THE COLUMBIA AND THE SHAMROCK, 1899. Sir Tom could have used as an alibi for the loss of his first challenge the fact that the *Shamrock*'s designer-builder, William Fife Jr., had pledged to be among the afterguard, became ill, and missed all the races. The challenger made no excuses, and at a farewell banquet, he announced: "Gentlemen, I shall be back." (Rochette photo.)

THE *ERIN* AND EXCURSION BOATS ON THE RUN HOME OFF SANDY HOOK, NEW JERSEY. (Rochette photo.)

Four

THE HERRESHOFF
DEFENDERS:
SHIP SHAPE 'N BRISTOL FASH'N

THE FIRST HERRESHOFF SHOP, C. 1870. John Brown Herreshoff started a boat-building business here in the early 1860s that was destined to bring fame to the Herreshoff name and to Bristol. At this time about six men were employed. According to the author of a 1903 *Bristol Phoenix* article, "What can be seen of the boat in the shop shows the style of yachts built at that time and does not look very much like those turned out later at the Herreshoff shops."

Before being acquired by Herreshoff, this building had been used as a pin factory by John Slocum, as a tannery by Hugh N. Gifford, as a nail-manufactory by Samuel G. Reynolds (it is said that Reynolds invented the machinery that enabled him to produce the first headed and pointed wrought-iron nails), and as a silk-producing mill. Thomas J. Thurston was the first to build boats here. By the time this photograph was taken, the wharf was in dilapidated condition and was known to neighborhood boys as Richmond's Wharf. Much later, a part of the south construction shop stood on the site of the building to the left.

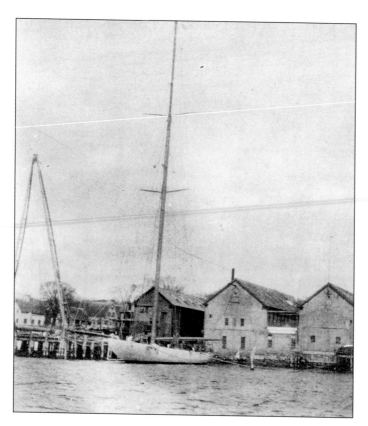

A Harbor View of Herreshoff's Construction Shops in 1903. The 90-foot sloop yacht *Constitution* is being rigged at the north pier. For more on the Herreshoff Mfg. Co., see Richard Simpson's other Arcadia books: *Bristol Vol. I* (1996) and *Bristol Vol. II* (1998).

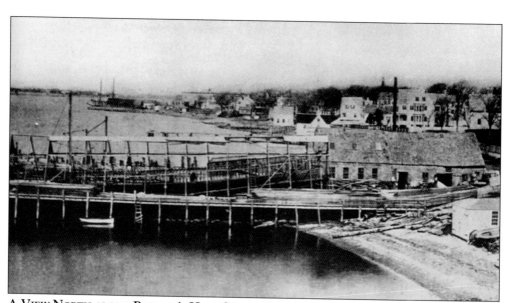

A View North along Bristol's Hope Street Shore and the Shops of the Herreshoff Boat Yard, c. mid-1870s. Bristol Harbor is on the left.

A VIEW SOUTH OF THE HERRESHOFF MFG. CO., BRISTOL HARBOR, C. 1910. Out of these Bristol sheds sailed the Seventies, as graceful as a beautiful women gliding over a ballroom floor. There were four of them: the *Mineola*, built for August Belmont; the *Rainbow*, built for Cornelius Vanderbilt; the *Virginia*, built for W.K. Vanderbilt Jr.; and the *Yankee*, built for Harry Payne Whitney and Herman Duryea. They were built on a one-design basis, and suggested a merging of the lessons learned from both the *Defender* and the *Columbia*.

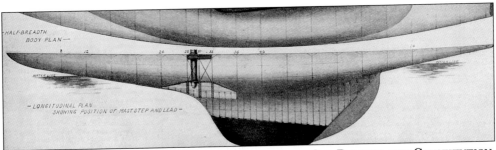

NAT HERRESHOFF'S UNSUCCESSFUL CONTENDER FOR THE CUP DEFENSE, THE CONSTITUTION. This May 11, 1901 *Scientific American* illustration of the *Constitution*'s half-breadth and longitudinal plans shows the mast step and lead positions.

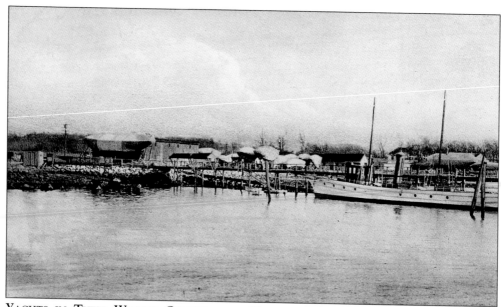

YACHTS IN THEIR WINTER QUARTERS AT HERRESHOFF'S WALKER'S COVE IN BRISTOL HARBOR. At the time, Herreshoff offered clients winter storage in the water (wet storage), under canvas in the open, or covered in steel frame sheds.

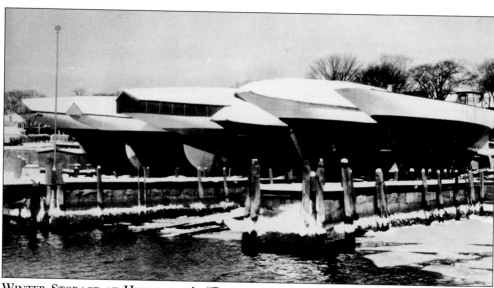

WINTER STORAGE AT HERRESHOFF'S "PEACOCK ALLEY." Huddled and secure, from left to right, are the *Resolute, Thistle, Vanitie, Ramallah, Weetamoe,* and *Yankee.*

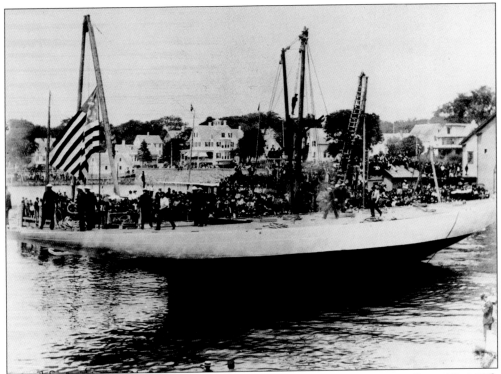

LAUNCHING THE DEFENDER BEFORE A LARGE GATHERING OF BRISTOLIANS, JUNE 29, 1895. During her launching, the *Defender* became stuck on the submarine railway. A diver discovered a protruding bolt blocking the cradle, a problem easily corrected.

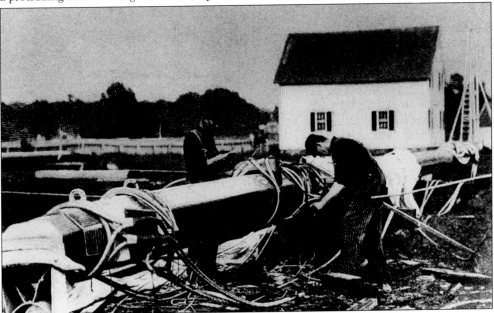

RIGGING THE DEFENDER'S MAST IN THE HERRESHOFF YARD, 1895. The *Defender's* specifications are as follows: overall length, 123 feet; length at waterline, 88 feet, 5 inches; beam, 23 feet; draft, 19 feet; and sail area, 12,602 square feet.

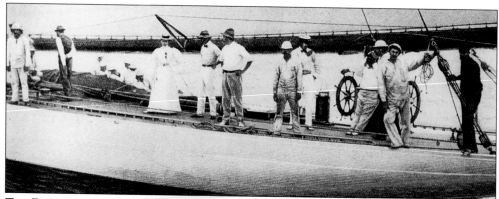

THE DEFENDER. Prior to her 1895 race with the *Valkyrie*, the *Defender* is shown taking a leisurely sail with family members of her syndicate owners. From left to right are N.G. Herreshoff, Mrs. Iselin, Woodbury Kane, William K. Vanderbilt, C. Oliver Iselin, and Captain Haff (behind crewmen with his hand on the wheel). The double wheel was for an extra helmsman in heavy weather.

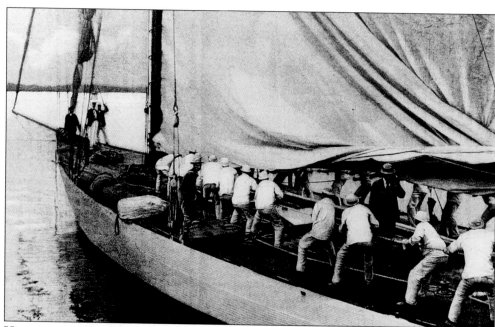

HOISTING THE DEFENDER'S MAINSAIL, 1895. Her builder, N.G. Herreshoff, is in a straw hat. The *Defender* was built with topside plates of aluminum and bottom plates of manganese bronze. About 17 tons of dead weight was saved by using these metals.

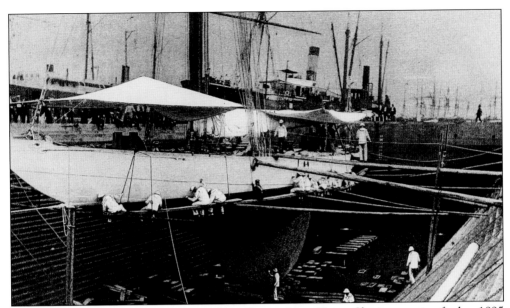

THE DEFENDER IN DRY DOCK AT THE ERIE BASIN, NEW YORK. She is preparing for her 1895 race with the *Valkyrie III*. The *Defender*'s manganese bronze bottom plating was very expensive and strong by the standards of the day. However, because of corrosive electrolysis set up between diverse metals, by the end of the decade the *Defender* was literally falling apart and was scrapped on City Island. (*Scientific American* photo.)

THE DEFENDER WINS THE FIRST RACE. She beat the *Valkyrie III* by nearly nine minutes. In the 15-mile beat to windward, Captain Hank Haff split tacks and sailed away from the faster challenger; the *Valkyrie III* made the mistake of not covering. When they crossed again, the *Defender* just barely made it across the challenger's bow and stayed ahead to win. (Rochette photo.)

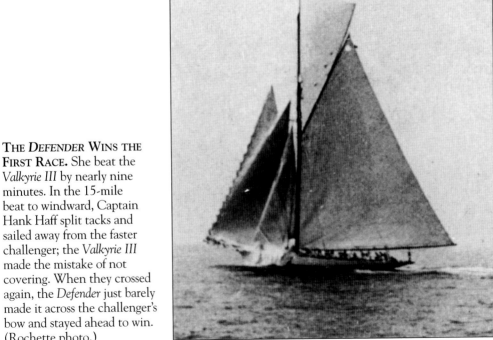

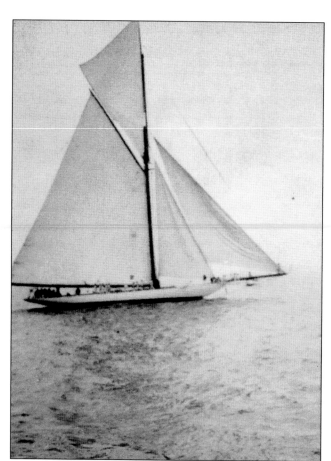

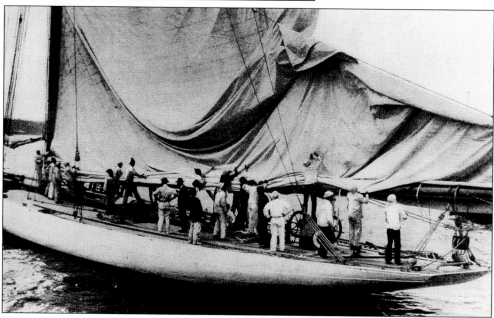

HOISTING THE *DEFENDER*'S MAINSAIL BEFORE HER 1895 RACE WITH THE *VALKYRIE III*.

ON THE COURSE, OCTOBER 16, 1899. The *Columbia* is shown hoisting her sails in the midst of the spectator fleet of excursion boats. (Rochette photo.)

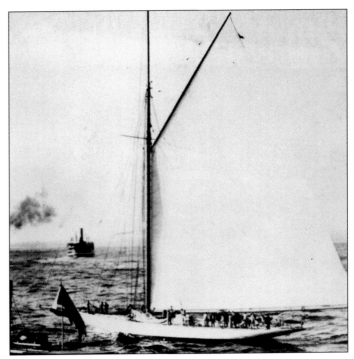

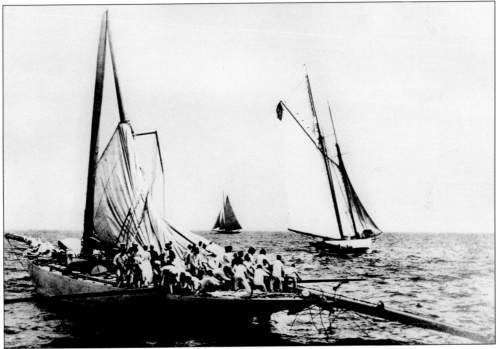

THE COLUMBIA DISMASTED, 1899. The *Columbia* had steel topsides and manganese bronze below the waterline. In 1899, she defeated Lipton's first challenge in three races. The *Columbia*'s statistics are as follows: overall length, 131 feet; waterline length, 89 feet, 8 inches; beam, 24 feet; draft, 19 feet 3 inches; and sail area, 13,135 square feet. (*Scientific American* photo.)

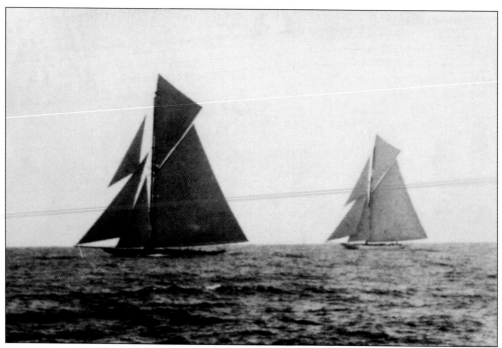

THE *SHAMROCK II* LEADING THE *COLUMBIA*, SEPTEMBER 28, 1901. Immediately after the 1899 race, Lipton began planning for 1901. He commissioned George Watson to design the 137-foot *Shamrock II*. (Rochette photo.)

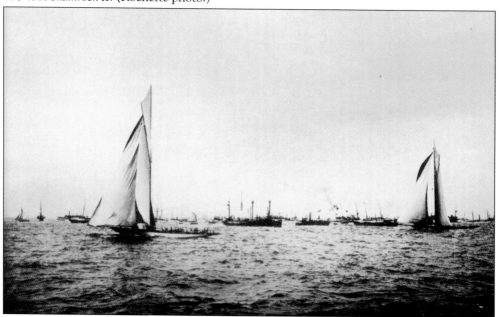

THE *COLUMBIA* AND THE *SHAMROCK II* AT THE END OF THEIR FIRST RACE FOR THE AMERICA'S CUP, SEPTEMBER 28, 1901. A new NYYC syndicate was formed, and Herreshoff was commissioned to out-design the *Columbia*, the result of this commission being the *Constitution*. A third contender for the defense, the *Independence*, was built by Bostonian Thomas W. Lawson. (Rochette Photo.)

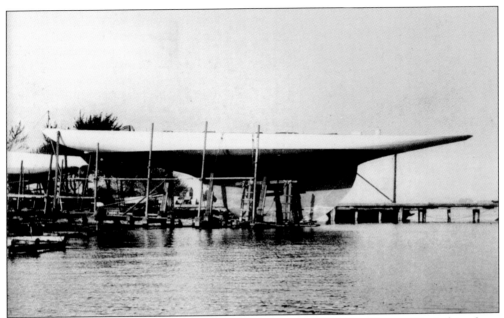

THE COLUMBIA HAULED OUT AT CITY ISLAND, AFTER THE 1901 CUP RACES. The *Independence* did not race in any official trials. She did, however, sail in six races, four against both the *Columbia* and the *Constitution* and two against the *Columbia* alone—and lost every contest. The old Herreshoff design, the *Columbia*, was finally selected defender.

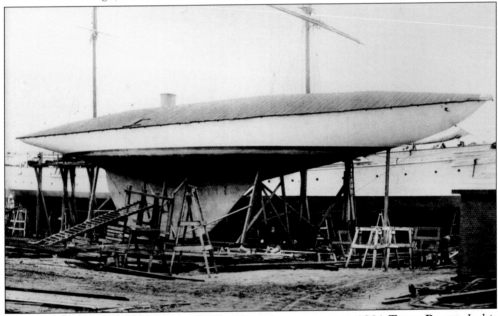

THE CONSTITUTION HAULED OUT AT NEW LONDON AFTER THE 1901 TRIAL RACES. In his *Showdown at Newport* (Walden Publications, 1974), Geoffrey F. Hammond says of the trials between the Herreshoff-designed *Constitution* and *Columbia*, "[Columbia's] skipper Charley Barr showed that aggressive steering tactics combined with quick, efficient crew work could give an old boat dominance over a new [boat]. Barr bullied and bluffed *Constitution*'s Rhodes at nearly every start . . ."

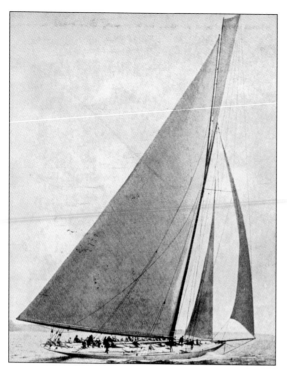

THE *RELIANCE*, 1903. She was said to be the fastest boat in the world, and was certainly the most spectacular yacht in the long tradition of the America's Cup, being far larger than all the others. From the tip of her bowsprit to the end of her main boom was 201 feet, 9 inches, and she was 89 feet, 8 inches on the water. Towering 196 feet above the water, she carried an incredible 16,160 square feet of sail. The mainsail was the largest sail ever set on a single mast. The club topsail was equal to the entire sail area of a modern Twelve Meter yacht.

THE *RELIANCE*. One man stood aloft at the throat of the gaff to shift the foot of the topsail as the *Reliance* tacked. She was designed and built in 1903 by Nathanael G. Herreshoff. Skippered by Charlie Barr, one of the most famous yacht skippers of all America's Cup races, she beat Lipton's *Shamrock III* three times straight. (Rochette photo.)

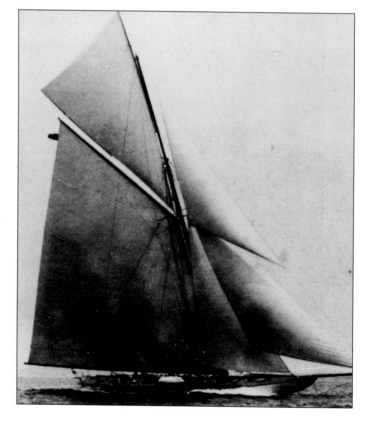

THE WORLD'S FASTEST SAILING YACHT.
The *Reliance* was extremely flat with a
shallow, skimming-dish underbody and
a thin, deep keel. Her steel mast was of
engineering perfection, and to Captain Nat's
credit it withstood the rigors of the entire
summer's racing. The inset portrait is of the
Reliance's manager, C. Oliver Iselin.

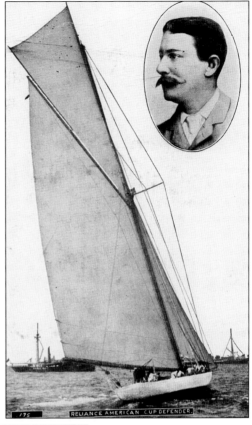

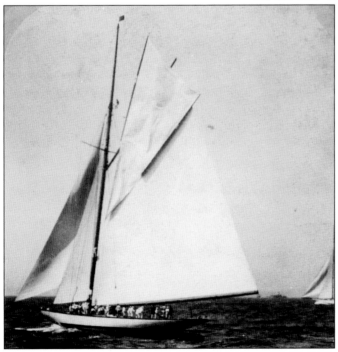

**RELIANCE CROSSES THE
LINE; THE SHAMROCK III
LOOSES HER WAY.** Thomas
Lipton's hopes were up
after being so close in 1901,
and he was back with the
Shamrock III. In the first
race a shift of wind and
poor handling on the part
of the challenger allowed
the defender to win by 7
minutes. In the second race,
the *Reliance* led all the way
and won by one minute, 19
seconds. In the third race,
with the *Reliance* in the
lead, dense fog rolled over
both the boats, and the
Shamrock III lost her way,
completely missing
the finish line.
(Rochette photo.)

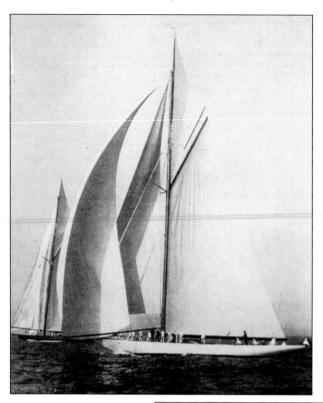

THE *RESOLUTE*, SKIPPERED BY CHARLES FRANCIS ADAMS II. The *Resolute* won the last three races of the series with the *Shamrock IV*. The challenger won the first two races. During the first race on July 15, 1920, the *Resolute*'s halyard for the mainsail parted at the winch, and the defender lost her canvas. Lipton had won his first race against an American defender. The only previous win by a challenger was in 1871 between the *Livonia* and the *Columbia*.

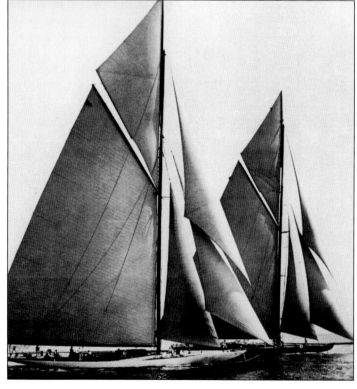

THE 1920 MATCH BETWEEN LIPTON'S *SHAMROCK IV* AND HERRESHOFF'S *RESOLUTE* (FOREGROUND). The match was the first in which amateur skippers commanded and the last sailed in New York waters. In the second race the challenger pointed higher on the beat and Adams chose not to cover. A favorable windshift allowed the *Shamrock IV* to take the lead, which she never lost. But the *Resolute* came back to take the next three races, thereby winning the series.

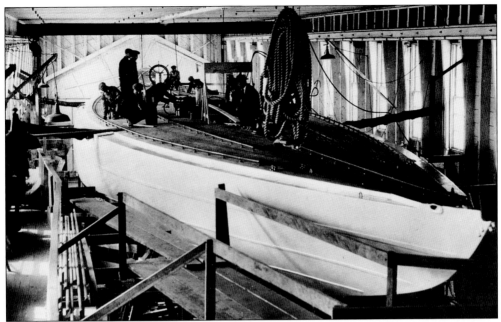

THE *ENTERPRISE*. She is shown in 1930 in Herreshoff's south shop just prior to her launching. She was the first of three J Boats skippered by Harold S. Vanderbilt, the others being the *Rainbow* in 1934 and the *Ranger* in 1937. All three were designed by W. Starling Burgess; Olin Stephens was co-designer of the *Ranger*.

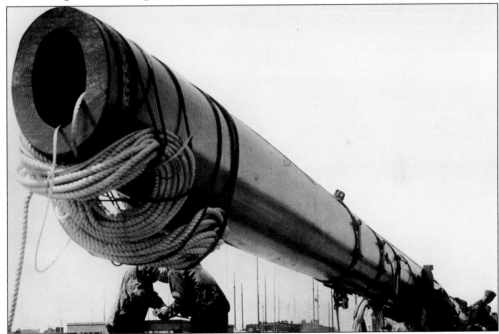

THE HOLLOW MAST OF THE *ENTERPRISE*. The mast is shown on a Newport dock being worked on by yard hands and crew members. The J Boats had conventional modern Marconi rigs, being without gaff and topsail. The jib sails were similar to the older boats without bowsprits. The *Enterprise*'s mast was 152 feet tall and had spreaders for support and much steel cable rigging.

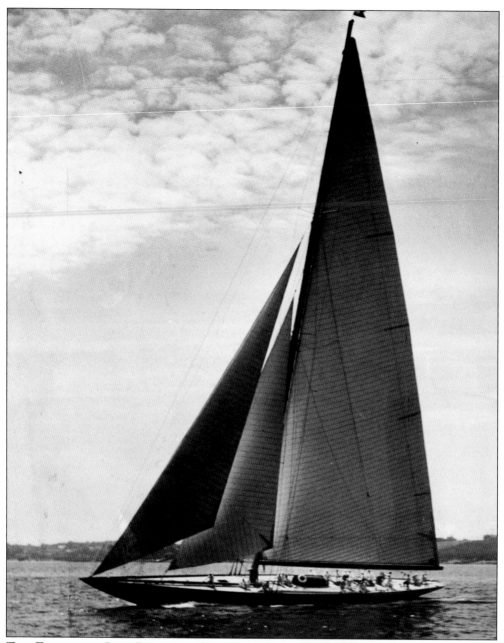

THE *ENTERPRISE* JUST PRIOR TO THE 1930 RACES. During the summer of trials, Harold Vanderbilt made continual adjustments to his vessel. The J Class boats were built under the universal rule of measurement and were raced boat for boat without time allowances. The *Enterprise* beat the *Weetamoe, Yankee*, and *Whirlwind* for the right to defend the Cup. In 1930 the Cup races were shifted from Sandy Hook, New Jersey, to Newport, Rhode Island.

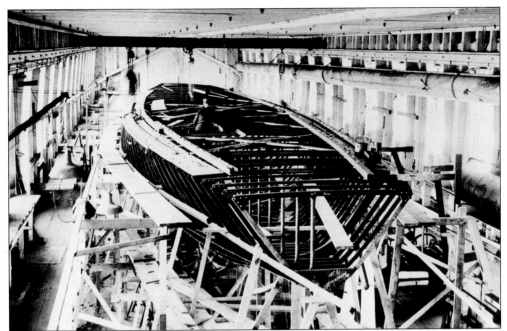

THE STEEL FRAME OF THE RAINBOW UNDER CONSTRUCTION IN THE SOUTH SHOP OF THE HERRESHOFF YARD, MARCH 1934. The *Rainbow* was plated with steel above the water line and bronze below. After beating the *Yankee* by a narrow margin in the trials, the *Rainbow* lost the first two Cup races to the English *Endeavour I*, which was sailed by owner-skipper Thomas Sopworth, an aircraft manufacturer.

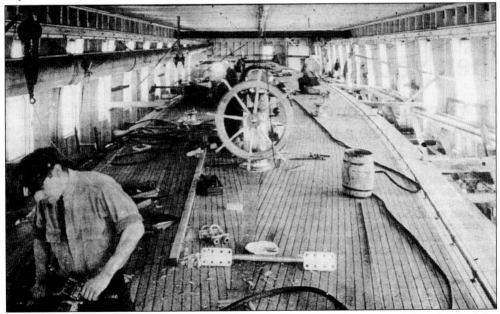

A HERRESHOFF EMPLOYEE WORKING ON THE DECK OF THE RAINBOW. The wheel of the *Enterprise* was used on the new boat. The *Rainbow* was handled by Harold Vanderbilt, who managed to win the next four races. The fourth race, however, was marred by a protest from the challenger, which the Race Committee refused to hear.

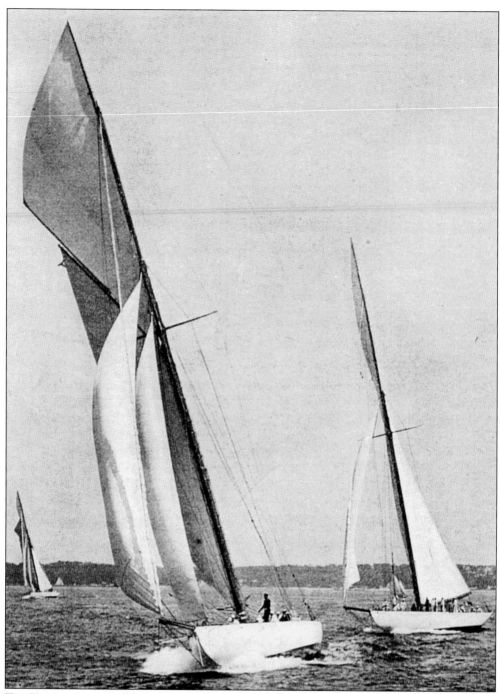

THE YANKEE AND THE RAINBOW STANDING OUT OF GLEN COVE IN LIGHT WINDS. In the 1937 trials the *Rainbow*, owned by Chandler Hovey, lost out to Vanderbilt's *Ranger*. The *Rainbow's* specifications are as follows: length overall, 126 feet, 7 inches; waterline length, 82 feet; beam, 21 feet; draft, 14.5 feet; and sail area, 7,572 square feet on a 168-foot spar.

LAST MINUTE ADJUSTING OF THE ROD RIGGING ON THE *RAINBOW*'S DURALUMIN MAST. The *Rainbow*, having been launched, awaits her spar to be put in place by Herreshoff's powerful latticed-steel sheer legs.

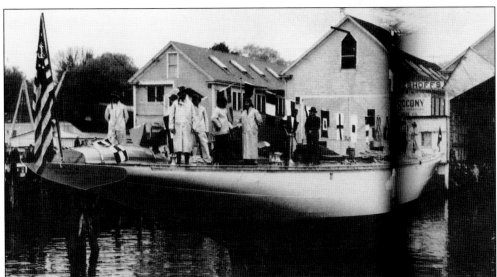

LAUNCHING THE *RAINBOW*. The launching of a Cup defender in Bristol was generally acknowledged to be a holiday—at least a holiday spirit always prevailed. At the Herreshoff yard, launchings most often took place in the early morning hours with colorful ceremonies.

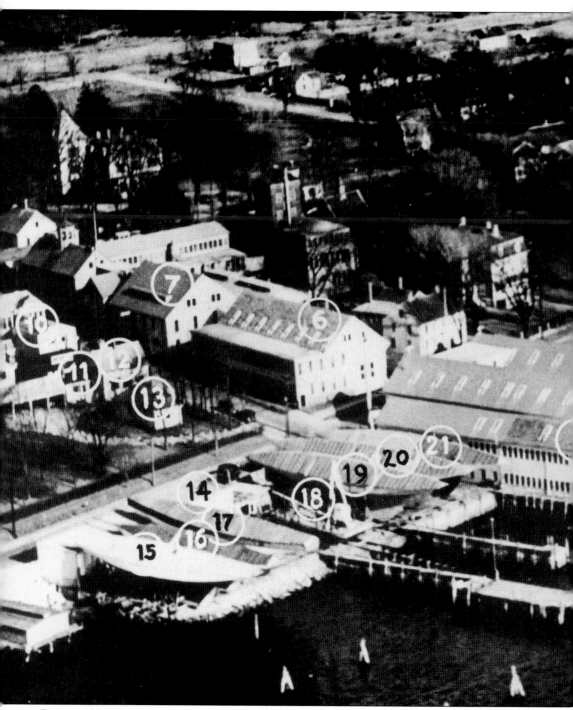

BRISTOL HARBOR AND THE HERRESHOFF MFG. CO. ON HOPE STREET. The legend for this aerial photograph is as follows: 1. giant shear legs; 2. paint mill and finishing department; 3. south construction shed; 4. north construction shed; 5. cabinet shops and mill; 6. east shop and mould lofts; 7. east storehouse; 8. sail lofts and machine shop; 9. foundry; 10. main offices;

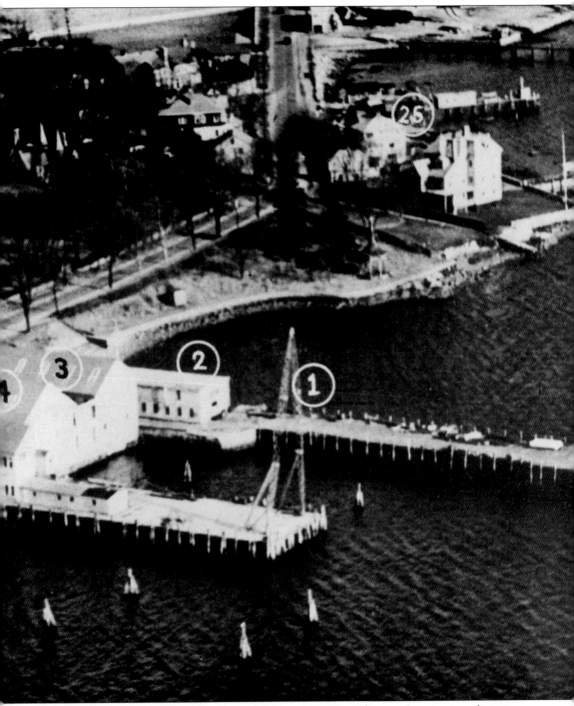

11. forge shop; 12. drafting cottage and laboratory; 13. yacht crew's recreational cottage; 14. locker shed; 15. the *Resolute*; 16. the *Thistle*; 17. the *Vanitie*; 18. the *Useful*, the shop lighter; 19. the *Rainbow*; 20. the *Weetamoe*; 21. the *Enterprise*; and 25. "Love Rocks," the home of N.G. Herreshoff.

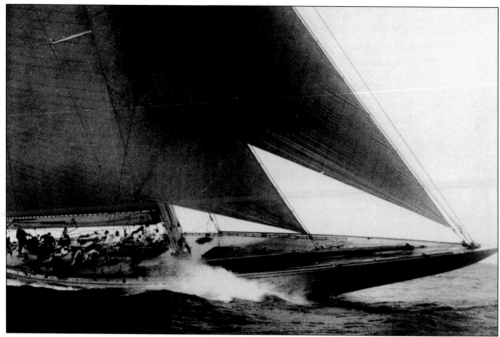

THE RAINBOW'S SHAKEDOWN CRUISE IN NARRAGANSETT BAY. She handles smartly, knocked down with rails awash. The *Rainbow's* designer, W. Starling Burgess, keeps an eagle eye aloft as Commodore Vanderbilt puts his new J Class sloop through her paces off Newport. The Herreshoff-built *Weetamoe* (below), owned by Frederick H. Prince, Esq., is astern on another tack.

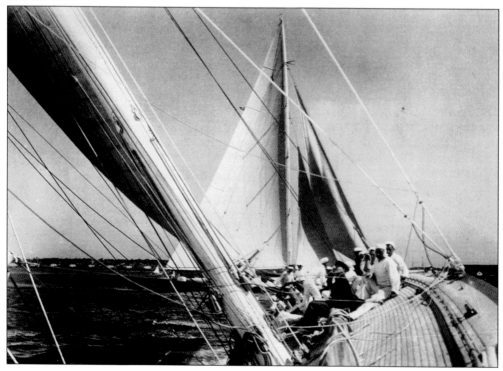

THE HERRESHOFF YARD, 1937. The
Weetamoe sits in storage (foreground), while
the British *Endeavor II* is readied for racing.
Though most of the America's Cup hoopla
gravitated to the Newport end of the bay,
the upper bay has, since 1893, played a quiet
but key and serious roll in sailing's greatest
spectacle. (*Bristol Phoenix* photo.)

THE HERRESHOFF YARD, 1937. T.O.M. Sopworth, head of the British challenge, and members
of the British crew confer during the *Endeavor II*'s outfitting after her trans-Atlantic crossing
under her own sails. Though the races were held out of Newport, "the City by the Sea" had no
boat yards to compare with Bristol's Herreshoff yard. (*Bristol Phoenix* photo.)

THE RANGER. The 1937 defender (stern showing in the shed), the *Ranger* is seen with her trial horse, the *Rainbow* (foreground), the 1934 defender. The British flag flying signals the presence of the challenger at the Herreshoff yard. Not only were some of the most grand Cup defenders designed and built in Bristol, many were stored and maintained there as well. (*Bristol Phoenix* photo.)

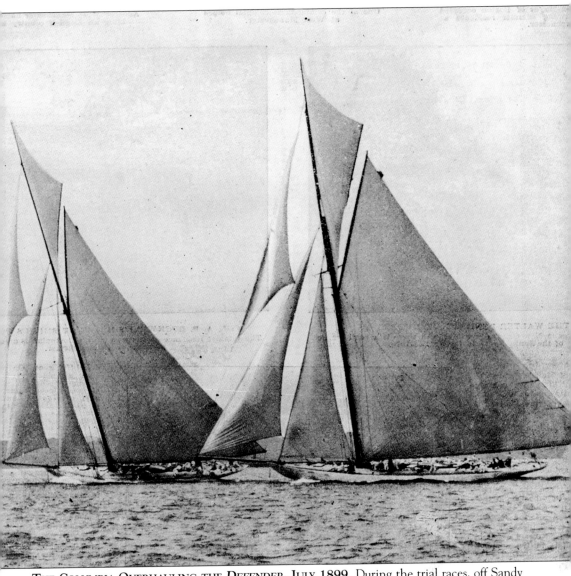

THE COLUMBIA OVERHAULING THE DEFENDER, JULY 1899. During the trial races, off Sandy Hook, New Jersey, the contests were between the skippers. Here, the *Defender* is almost blanketing the *Columbia*, and (it was said) a little later the latter was obliged to go about to obtain the weather gauge of her fleet rival. The contenders were followed throughout the race by a large number of yachts, tugs, and observations steamers, from one of which this photo for the *Boston Sunday Journal* was taken.

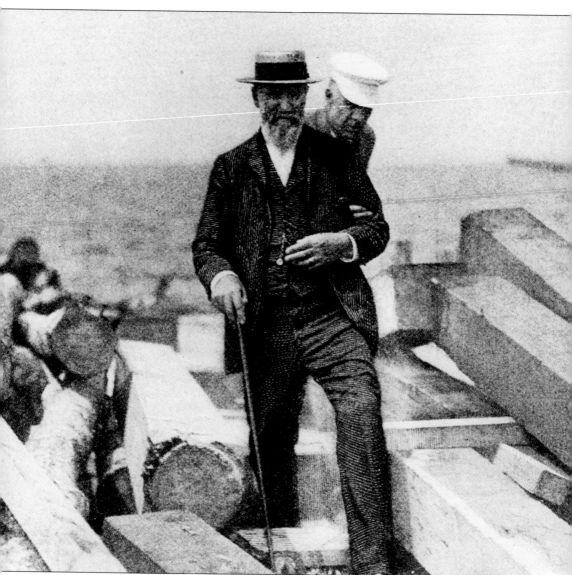

JOHN BROWN HERRESHOFF, 1841–1915. The Herreshoff boat yard eventually employed more than 300 men who worked under strict but fair rules. J.B. Herreshoff, as president, concentrated on the business end of the company while his brother Nathaniel tended to the supervision of the technical aspects of boat construction.

Five

THEY ALSO RAN

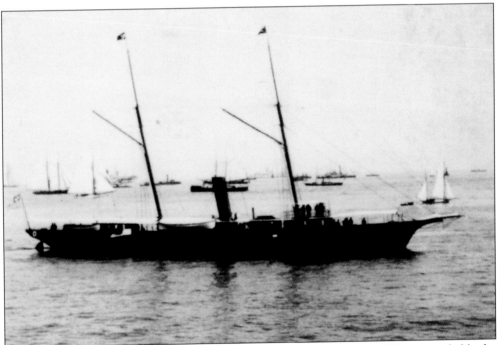

THE ELECTRA. Built for Elbridge T. Gerry, the *Electra* came out in 1884. She was probably the first pleasure yacht that was fully electrified; she carried a full complement of incandescent lights and a 15,000-candle-power searchlight. The *Electra* was the flagship of the NYYC from 1886 to 1892; she was a familiar sight on NYYC cruises and at America's Cup races for some 25 years. (Rochette photo.)

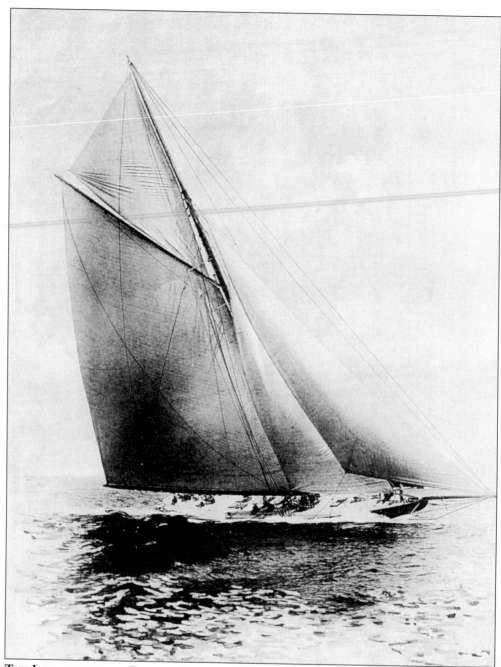

THE INDEPENDENCE, A BOSTON CANDIDATE FOR THE 1901 CUP DEFENSE, ON HER MAIDEN TRIAL IN MASSACHUSETTS BAY. In his *An Introduction to Yachting*, L. Francis Herreshoff writes: "The new yacht was named *Independence* and all Massachusetts thought she would as easily beat all the New York owners' boats as General Paine had with *Puritan, Mayflower* and *Volunteer*, and this feeling was so strong that fifty years later you would occasionally meet Bostonians who thought *Independence* was the fastest Cup boat of 1901. But Mr. Crowninshield [designer and builder] was to have all the troubles that are usual with a large racer whose hull was built by one concern, and spars, rigging, fittings, and sails by other separate companies."

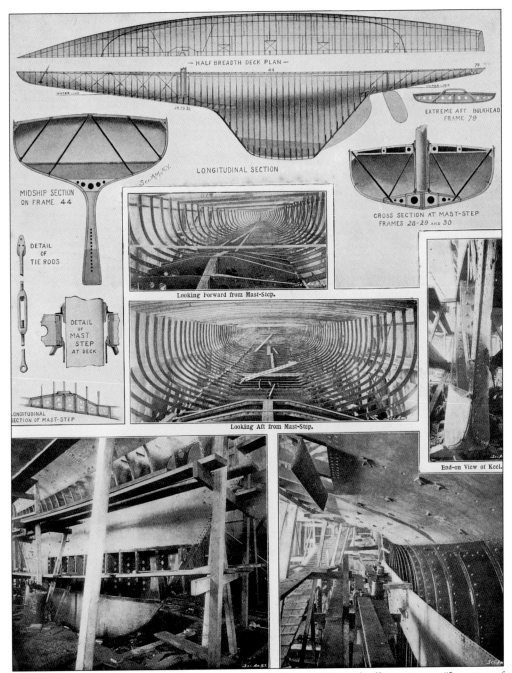

- HALF BREADTH DECK PLAN -

WATER LINE

EXTREME AFT BULKHEAD FRAME 79

LONGITUDINAL SECTION

MIDSHIP SECTION ON FRAME 44

CROSS SECTION AT MAST-STEP FRAMES 28-29 AND 30

DETAIL OF TIE RODS

DETAIL OF MAST STEP AT DECK

LONGITUDINAL SECTION OF MAST-STEP

Looking Forward from Mast-Step.

Looking Aft from Mast-Step.

End-on View of Keel.

THE CONSTRUCTION OF THE INDEPENDENCE. L. Francis Herreshoff continues: "In spite of this *Independence* was sailing early in June [1901]. I must say that when I saw the picture of the *Independence* I thought my father's [Nathanael G. Herreshoff] Cup boats would be beaten by *Independence*, but things turned out quite differently for she had structural trouble and leaked badly; she did not steer well, and her very flat model had so much wetted surface that she was very dull in light weather." (Scientific American Photo.)

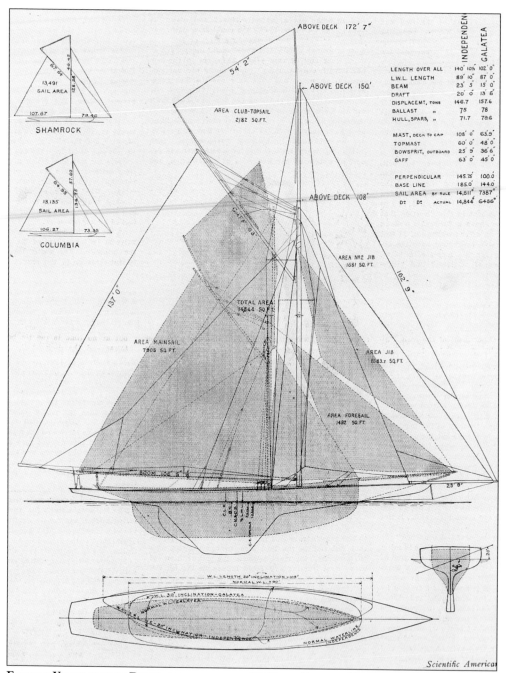

	INDEPENDENCE	GALATEA
LENGTH OVER ALL	140' 10⅛"	102' 0"
L.W.L. LENGTH	89' 10"	87' 0"
BEAM	23' 5"	15' 0"
DRAFT	20' 0"	13' 6"
DISPLACEM'T, TONS	146.7	157.6
BALLAST "	75	78
HULL, SPARS, "	71.7	79.6
MAST, DECK TO CAP	108' 0"	63.9'
TOPMAST	60' 0"	48' 0"
BOWSPRIT, OUTBOARD	25' 9"	36' 6"
GAFF	63' 0"	45' 0"
PERPENDICULAR	145.75'	100.0
BASE LINE	185.0'	144.0
SAIL AREA BY RULE	14,611°	7387°
D! D! ACTUAL	14,844°	6486°

SHAMROCK

13,491 SAIL AREA

COLUMBIA

13,135 SAIL AREA

ABOVE DECK 172' 7"

ABOVE DECK 150'

AREA CLUB-TOPSAIL 2182 SQ.FT.

ABOVE DECK 108'

AREA N°2 JIB 1681 SQ. FT.

TOTAL AREA 14,844 SQ.FT.

AREA JIB 1383.1 SQ.FT.

AREA MAINSAIL 7905 SQ.FT.

AREA FORESAIL 1492 SQ.FT.

BOOM 108' 5"

Scientific American

FIFTEEN YEARS OF THE DEVELOPMENT OF THE 90-FOOT RACING YACHT. The *Galatea* (cutter, 1886) and the *Independence* (cutter-sloop, 1901) are compared in this image, which dates from April 13, 1901. (*Scientific American* photo.)

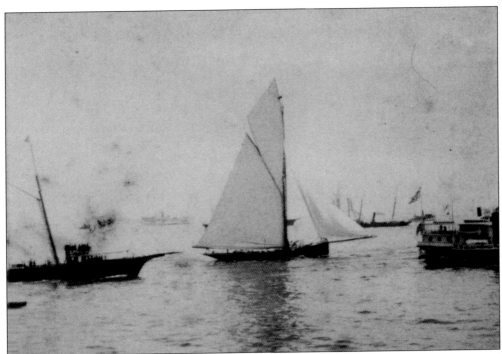

THE CHALLENGE. In 1885 the challenge came from England. Sir Richard Sutton, Royal Yacht Squadron, arrived with his yacht, the *Genesta*, skippered by J. Carter. (Rochette photo.)

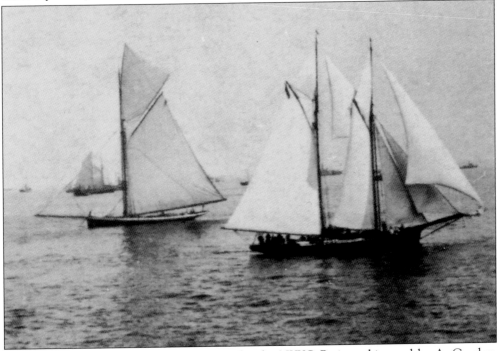

THE PURITAN (LEFT). The two races, won by the NYYC *Puritan*, skippered by A. Crocker, embraced the usual 32.6-mile triangular and the 40-mile windward-leeward courses. (Rochette photo.)

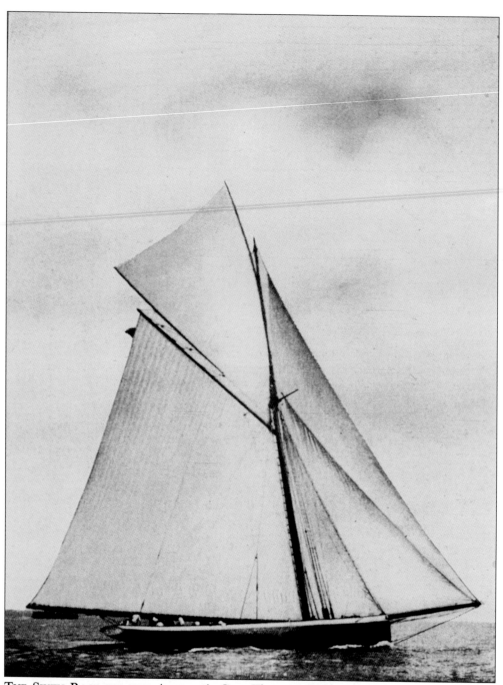

THE SIXTH RACE FOR THE AMERICA'S CUP. This race, held in 1885, was the closest ever sailed, and the NYYC was concerned about its possible outcome. The British sloop *Genesta* proved herself a marvel of speed and, although beaten in both races by the *Puritan* (above), she went on to win the Cape May and Brenton's Reef Cups. On September 8, Sir Richard Sutton, the *Genesta*'s owner, was told he could sail the course over and have the Cup, because the *Puritan* had been disqualified for fouling at the start. Sir Richard refused the offer, thus proving his gallantry and making himself very popular in America and amongst the world's yachtsmen.

THE 1886 CUP DEFENDER, THE MAYFLOWER. She was quite broad in the beam at 23.5 feet; her overall length was 100 feet; her length at waterline was 85.5 feet; and her sail area was 8,500 square feet. The *Mayflower* was designed by Edward Burgess and built at the Lawley Yard in Boston for Civil War General Charles Paine. She won the trials over the *Priscilla*, *Puritan*, and the New York Yacht Club's newly built *Atlantic*.

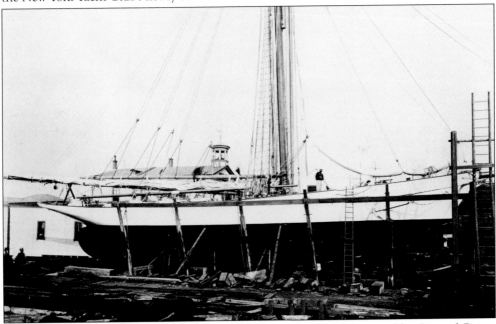

THE 1887 CUP DEFENDER, THE VOLUNTEER. The *Volunteer*, also owned by General Paine, was more narrow and deeper than her predecessor, the *Mayflower*. She had a clipper bow and more curve to her keel. Her overall dimensions are as follows: overall length, 105 feet, 3 inches; waterline length, 85 feet, 2 inches; beam, 23 feet, 2 inches; draft, 20 feet with centerboard; and sail area, 9, 271 square feet.

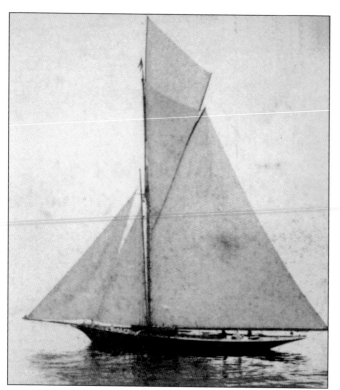

THE VOLUNTEER OUTSAILS THE FLEET. In his *An Introduction to Yachting*, L. Francis Herreshoff offered this humorous aside: "This was the last race for the America's Cup over an inside course for the many steam yachts and excursion steamers crowded and interfered with the racing yachts. General Paine had anticipated this trouble and had two large canvas signs painted to hang over the sides of *Volunteer* which said in large letters, 'Keep Astern.' (Apparently *Thistle* thought this meant her, too, for she also kept well astern.)" (Rochette photo.)

THE ROYAL CLYDE YACHT CLUB CHALLENGE FOR THE CUP, 1887. The Scots, complete with bagpipes and good spirits, arrived with their challenger, the *Thistle*. The *Thistle* was a beautiful big yacht over 108 feet on deck, but she lost both races over the usual courses to the defender, the *Volunteer*. The *Thistle* was later sold to Kaiser William and renamed *Meteor*. (Rochette photo.)

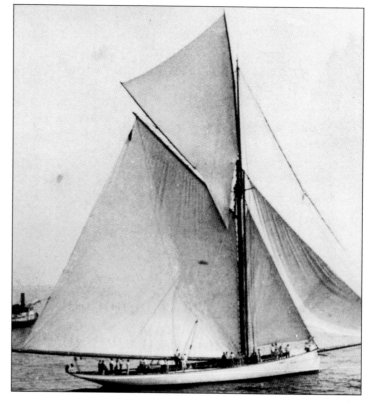

THE *VIGILANT* TESTS HER WINGS. The eighth challenge came in 1893 from Lord Dunraven, who after discussing terms for many months, sent over the *Valkyrie II*. Herreshoff's *Vigilant* proved the best boat and won four races from the challenger. (Rochette photo.)

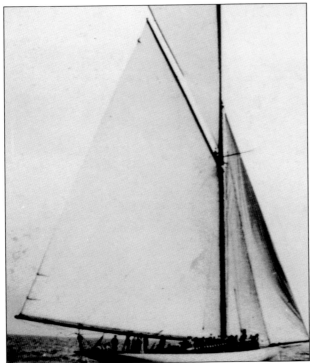

THE *VIGILANT* AND THE *COLONIA*. The *Bristol Phoenix* dated October 21, 1893, editorialized: "Nat Herreshoff won't give a fellow a chance to win. The comment was made by one of Capt. Nat's old-time adversaries. Lord Dunraven probably feels about that way himself. This year New York came to Bristol for a boat, and the result was *Vigilant* and *Colonia*, two of the dandiest flyers that the world has ever known. The *Vigilant's* success is Bristol's, for this is the birthplace of the yacht that outsails the world and brings fame to her designers." (Rochette photo.)

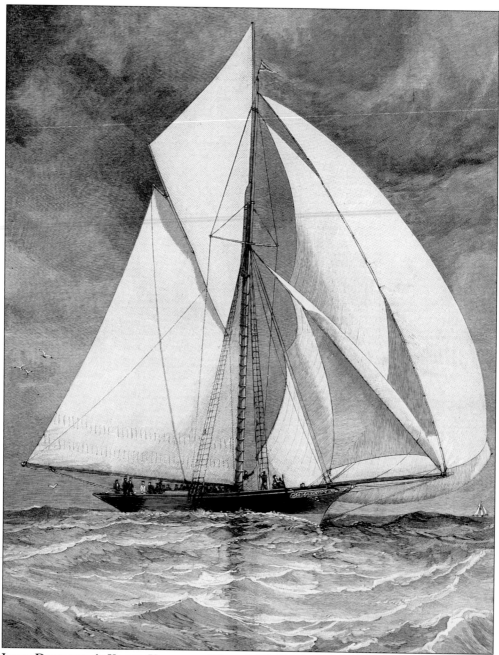

LORD DUNRAVEN'S YACHT VALKYRIE. (*Harper's Weekly* photo.)

A Close Brush as the *Shamrock I* and the *Shamrock III* Maneuver in Their 1903 Trial Races off Sandy Hook, New Jersey. (Rochette photo.)

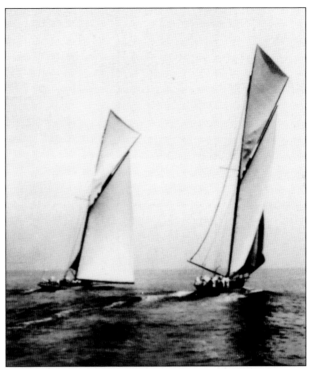

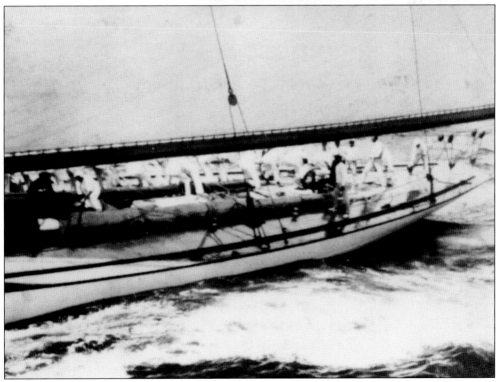

The Challenger, the *Shamrock III*, Crossing the Starting Line, August 22, 1903. (Rochette photo.)

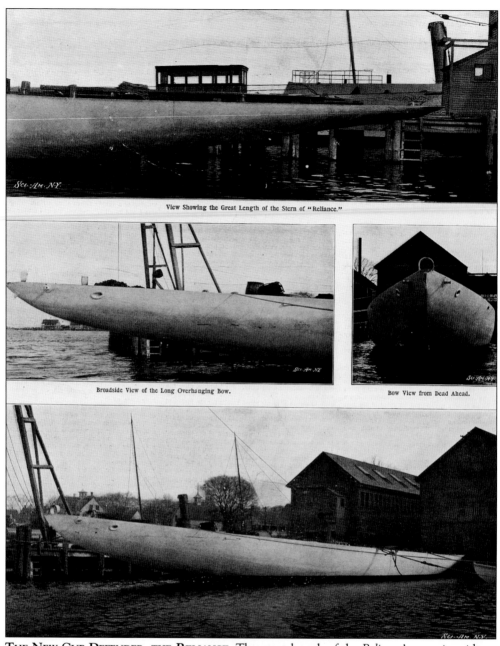

View Showing the Great Length of the Stern of "Reliance."

Broadside View of the Long Overhanging Bow.

Bow View from Dead Ahead.

THE NEW CUP DEFENDER, THE RELIANCE. The great length of the *Reliance*'s stern is evident. The location of all the photos on this page is the Herreshoff's Bristol boat yard. In some cases background clutter interferes with the *Reliance*'s profile. The cabin, in the top photo, belongs to a steam yacht berthed at the same pier. (*Scientific American* photo.)

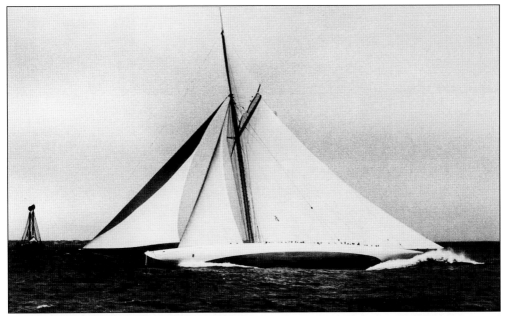

THE LARGEST YACHT. The *Reliance* was the most spectacular yacht in the long tradition of the America's Cup, being far larger than all the others. From the tip of the bowsprit to the end of the main boom was 201 feet, 9 inches. She towered 196 feet above the water and carried an incredible 16,160 square feet of canvas.

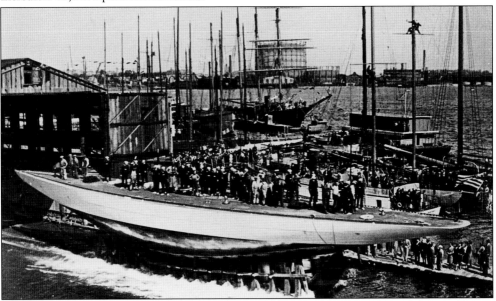

THE J CLASS CUP CONTENDER YANKEE AT HER LAUNCHING AT THE LAWLEY YARD IN BOSTON. She was owned by a Boston syndicate, designed by Frank Paine, and skippered by Charles Francis Adams. The *Yankee* lost to the *Enterprise* in the 1930 trial races. In 1934 she received extensive modifications, and, again skippered by Adams, narrowly missed being selected to defend the Cup against the British *Endeavour*. Undaunted, the *Yankee*'s new owner, Gerald Lambert, had her modified again for the 1937 Cup trials. She was unsuccessful for the third time.

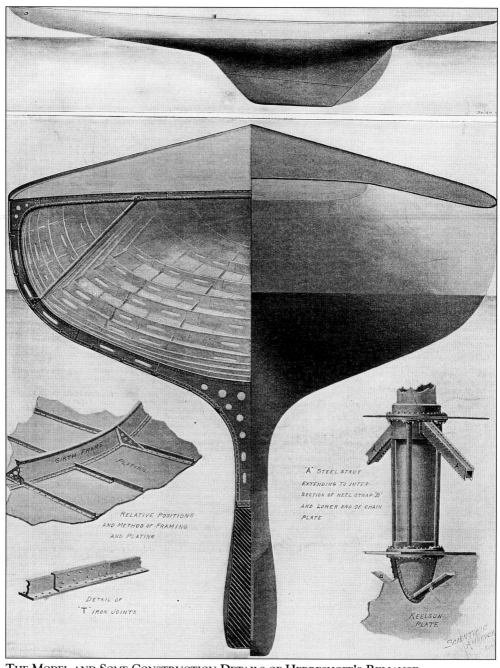

THE MODEL AND SOME CONSTRUCTION DETAILS OF HERRESHOFF'S RELIANCE.

Six

A GALLERY OF CHALLENGERS, DEFENDERS, AND CONTENDERS

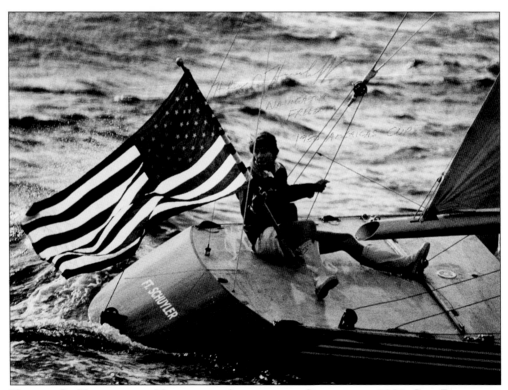

HALSEY C. HERRESHOFF, NAVIGATOR ABOARD THE SUCCESSFUL 1980 CUP DEFENDEFR
FREEDOM. Halsey is the grandson of Nathanael G. Herreshoff; he is a naval architect and
president of the Herreshoff Marine Museum and the America's Cup Hall of Fame. (*Providence
Journal* photo.)

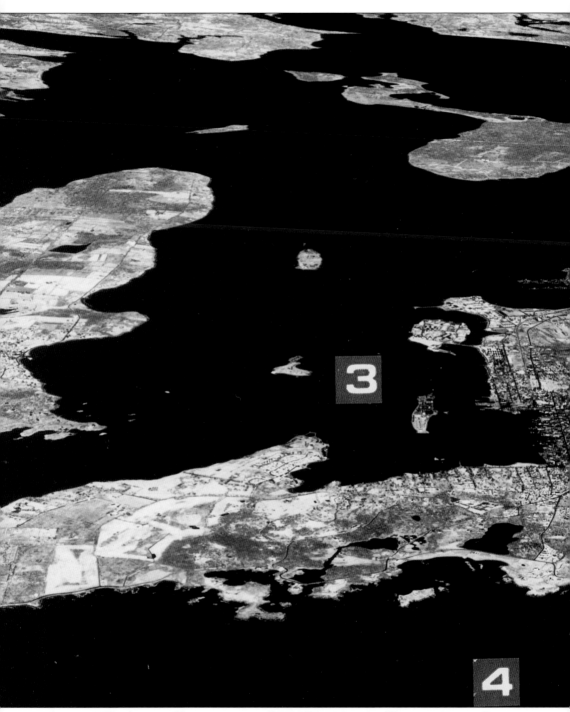

A c. 1950 Aerial View of the East Passage of Narragansett Bay and Aquidneck Island from 15,000 feet. The legend for this image is as follows: 1. Bristol, RI;

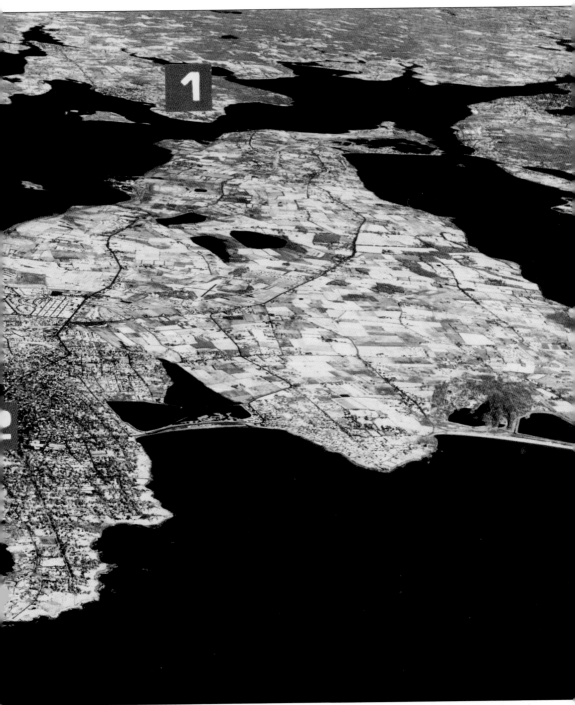

2. Newport, RI; 3. Newport Harbor; and 4. the Atlantic Ocean. (Newport County Chamber of Commerce photo.)

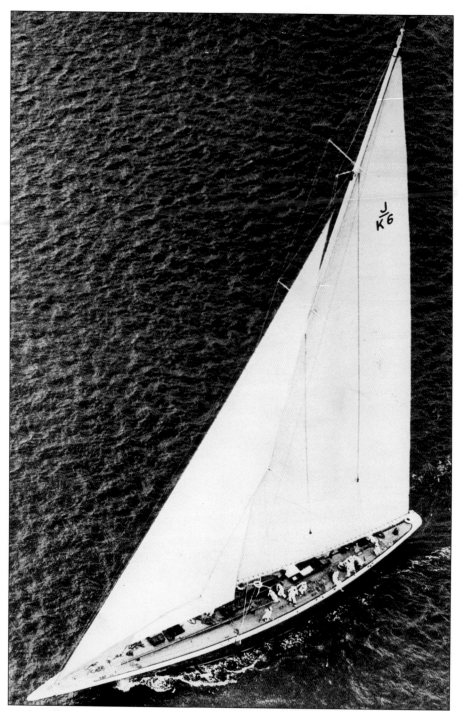

THE 1937 BRITISH CHALLENGER, THE *ENDEAVOUR II*, SKIPPERED BY THOMAS OCTAVE MURDOCH SOPWORTH. Sopworth brought prevailing aircraft technology to his two J-Class yachts, the *Endeavour* and the *Endeavour II*. These challenging boats were clearly outstanding for sophisticated technical innovations and advanced instrumentation that measured wind speed and direction. (AP photo.)

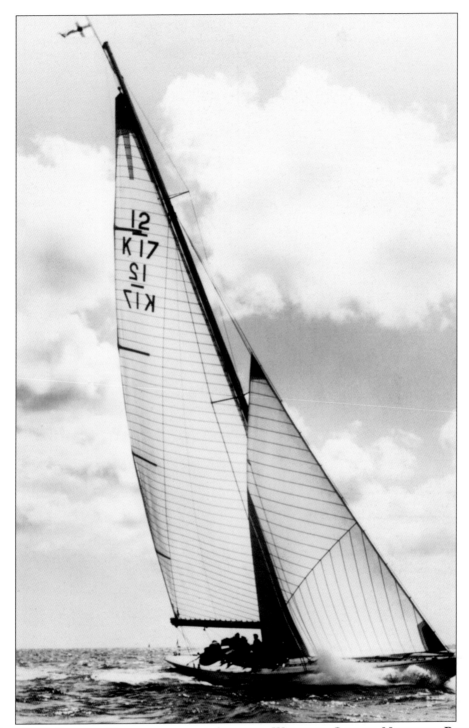

THE 1958 BRITISH CHALLENGER, THE *SCEPTRE*, WORKING OUT IN NEWPORT, RHODE ISLAND WATERS. THE *Sceptre* raced against the American defender, the *Columbia*, in Rhode Island Sound in September, when the revival of the America's Cup races, which were last held in 1937, resumed. (Photo: Valentine & Sons Ltd., Dundee and London.)

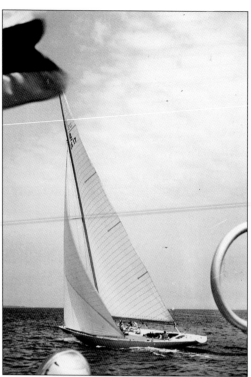

Long Island Sound, July 4, 1958. The American yacht *Weatherly* heels over in a breeze during a trial run from its yards in Stamford, Connecticut. The 12-meter craft was one of four American yachts that vied in trials to defend the Cup against the *Sceptre*. (AP photo.)

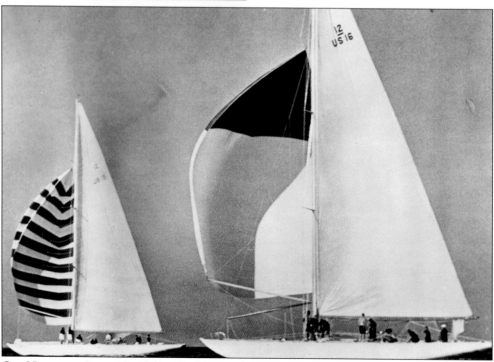

Off Newport, July 18, 1958. The *Vim*, with her striped balloon spinnaker flying, leads her rival, the *Columbia*, in a light breeze in the homeward leg of their defender trial race. The race was declared unofficial due to the elapsed time being over the allowed limit. (AP photo.)

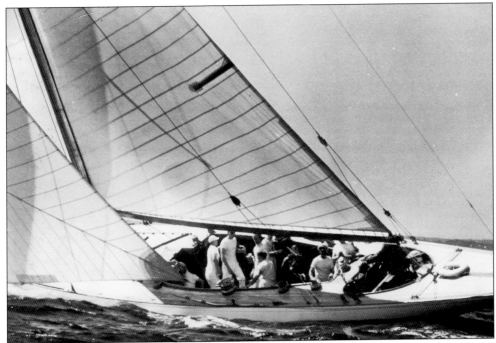

THE *SCEPTRE*, AUGUST 18, 1958. She tries her sails for the first time in American waters off Newport, Rhode Island. (AP photo.)

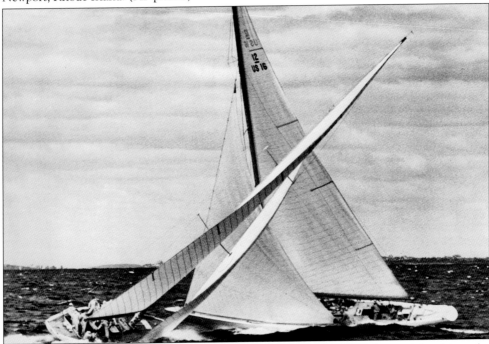

THE *VIM*, SEPTEMBER 13, 1958. The *Vim*, in the foreground, is forced to tack hard in order to give way to the *Columbia*, which has the right of way during elimination trials off Newport, Rhode Island. A collision was avoided by inches. The *Columbia* won this 24-mile race by 12 seconds and was chosen the America's Cup defender against Britain's *Sceptre*. (AP photo.)

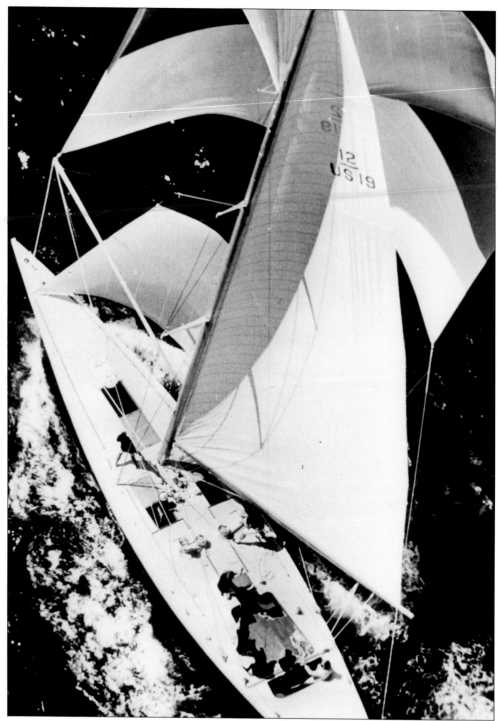

NEWPORT, RHODE ISLAND, JUNE 26, 1962. The American 12-meter yacht *Nefertiti* races against the *Weatherly* in the elimination races for the right to defend the America's Cup. The *Weatherly*, skippered by Emil "Bus" Mosbacher, eventually won the honor to race against Australia's *Gretel*. (AP photo.)

SEVEN-RACE SERIES, SEPTEMBER 23, 1958.
The American 12-meter yacht *Columbia* takes
a significant lead over the *Sceptre* in the first
of the seven-race series. Under skipper Briggs
Cunningham, the defender easily kept ahead over
the entire 24-mile course, and she finished with a
decisive 7 minute, 44 second lead.

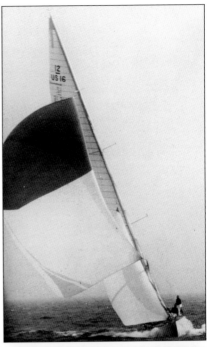

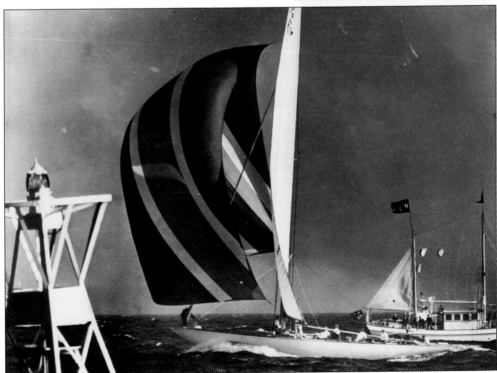

THE RACES, SEPTEMBER 25, 1958. The *Sceptre*, her tricolor spinnaker full to the 25-mile wind, crosses the finish line nearly a mile behind the *Columbia*. The finish line is marked by the buoy (left) and the New York Yacht Club Committee Boat (right). The committee boat raised her mizzen sail to help hold steady in the rough seas. (AP photo.)

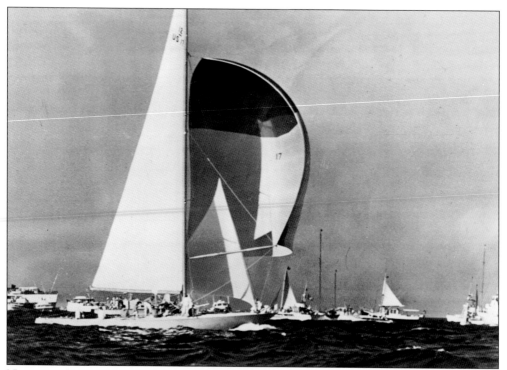

NEWPORT, RHODE ISLAND, JUNE 26, 1962. Cup defense contender *Nefertiti* is seen among the spectator fleet in her final competition against the *Weatherly*. (AP photo.)

AUGUST 8, 1962. The 12-meter sloop *Weatherly* goes on to defend the America's Cup against Australia's *Gretel* after defeating the *Nefertiti* in the defense trials in Rhode Island Sound. (AP photo.)

A SOUVENIR OF THE AUSTRALIAN CHALLENGE.
During Newport's 1962 summer of yacht racing, these wood-match boxes commemorating Australia's challenger, the *Gretel*, were available at Thames Street restaurants and bars.

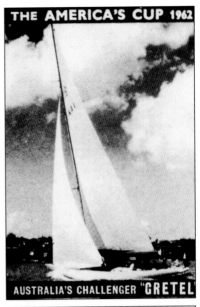

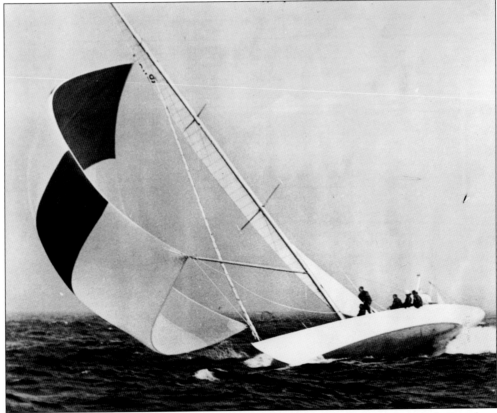

THE NEFERTITI DIPPING HER WINGS, AUGUST 20, 1962. The Boston America's Cup sloop *Nefertiti* heels over so far in high wind that water pours off her dripping spinnaker in the race she won against the *Weatherly* by over three minutes. Skipper Ted Hood drives her toward mark in wind gusting over 30 knots. (AP photo.)

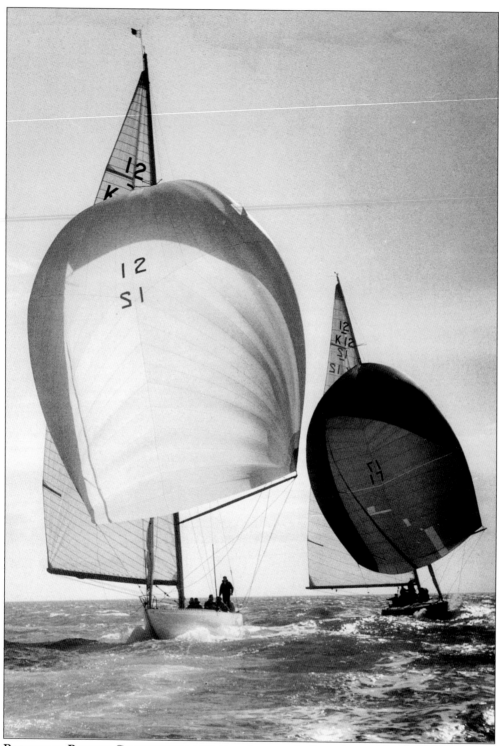

POTENTIAL BRITISH CHALLENGERS FOR THE AMERICA'S CUP, APRIL 22, 1964. The *Sceptre* (left) and the *Sovereign* glide through a trial race. (AP photo.)

STAMFORD, CONNECTICUT, MAY 19, 1964. The *American Eagle*, designed by A.E. (Rilly) Luders, idles in the water after being christened. She became another contender for the right to defend the America's Cup against England in the September races. (AP photo.)

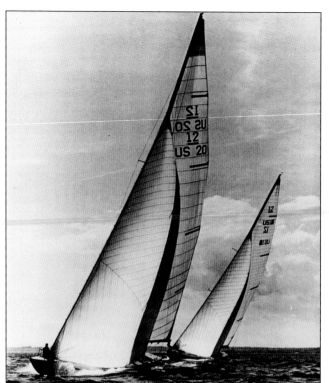

NEWPORT, RHODE ISLAND, JULY 7, 1964. The new American contender for the defense of the Cup, the *Constellation*, leads the way for the trial horse *Nereus* as they race close hauled on starboard tact. (AP photo.)

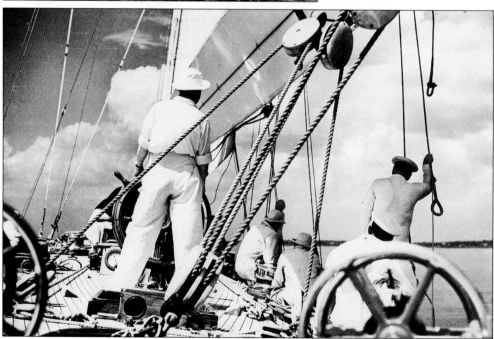

OYSTER BAY, NEW YORK, JUNE 9, 1964. Another contender, the *Nefertiti*, was pitted against the *American Eagle* in the first race of the preliminary trials to determine the yacht that would defend the Cup. The *American Eagle* showed her potential by outsailing both the *Constellation* and the *Columbia* in tune-up races. (AP photo.)

THE CONSTELLATION. The 12-meter yacht *Constellation* (US20), skippered by Robert N. Bavier Jr. and Eric Ridder, won the right to defend the Cup by defeating the *American Eagle, Columbia, Nefertiti,* and *Easterner* in the trial races off Newport, Rhode Island. (Photo: Newport County Chamber of Commerce.)

NEWPORT, RHODE ISLAND, JULY 10, 1964. The 1958 defender *Columbia* heels beyond 45 degrees in stiff wind as she beats her way around the weather mark in the trial race against the *Constellation.* Despite her supreme effort, the *Columbia* lost to her new rival. (AP photo.)

THE *AMERICAN EAGLE* (US21), JULY 8, 1964. She is seen here taking the lead from the 1958 defender, the *Columbia*, during the elimination trials off Newport, Rhode Island. (AP photo.)

NEWPORT, RHODE ISLAND, JULY 7, 1964. In this observation trial race, the *Constellation* (US20) appears to have an edge over the *Easterner* (US18) at the start. (AP photo.)

JULY 16, 1964, NEWPORT, RHODE ISLAND. On their way to a record finish, the *Nefertiti*'s crewmen (US19) battle to get her spinnaker full and drawing after rounding the weather mark, as her rival, the *Constellation*, squares away for the run downwind. The *Constellation* won this race by two seconds but was later technically disqualified for hitting the committee boat at the start. (AP photo.)

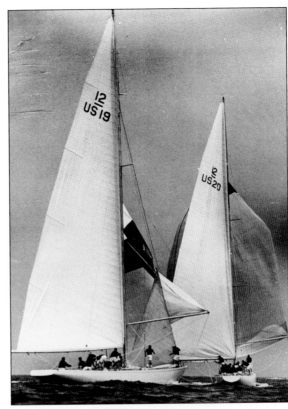

JULY 16, 1964, SPINNAKERS NECK AND NECK. Pictured are Boston's *Nefertiti* (US19) and New York's *Constellation* as they race almost bow to bow in the America's Cup trials. The *Constellation*'s skipper, Eric Ridder, was able to keep ahead, and he eventually won by two seconds in the 24-mile race, the closest finish in modern Cup contests. Skipper Ted Hood is shown trying to turn *Nefertiti* into the wind as much as possible to blanket or cut off air to his rival. (AP photo.)

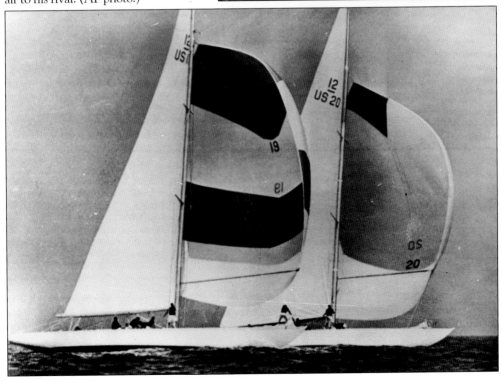

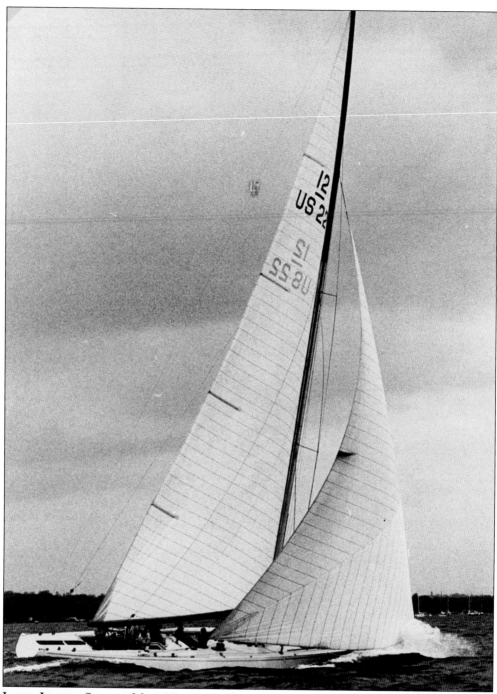

LONG ISLAND SOUND, MAY 29, 1967. Skipper Bus Mossbacher handles the newly built *Intrepid*'s double wheel during a trial run. The *Intrepid* defended the Cup against Australia's *Dame Pattie* in the September matches in Rhode Island Sound. (AP photo.)

THE CONSTELLATION, NEWPORT, RHODE ISLAND, AUGUST 14, 1967. The *Constellation*, the 1964 defender, is seen under her spinnaker during a workout in preparation for trials beginning on August 15. The 12-meter yacht was ostensibly a trial horse for the newer and supposedly faster yachts *Intrepid*, *Columbia*, and *American Eagle*. (AP photo.)

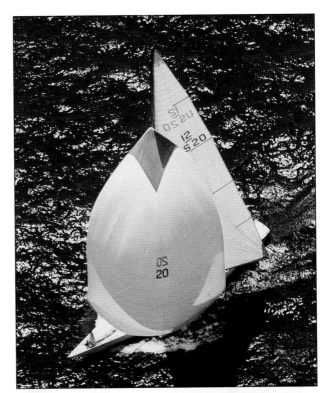

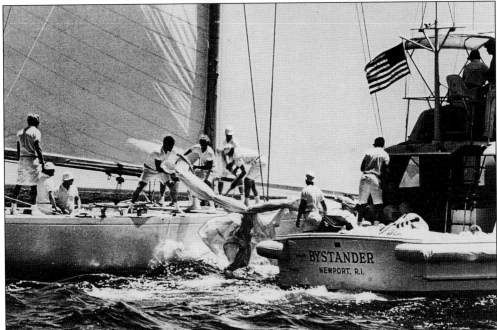

THE INTREPID. The wooden yacht *Intrepid*, designed by Olin Stephens, is shown receiving a sail from her tender, the *Bystander*. The *Intrepid* had a radically changed hull profile from previous 12-meter yachts. She easily defeated the three American contenders in the trials and the challenger, *Dame Pattie*, four times straight in the Cup races.

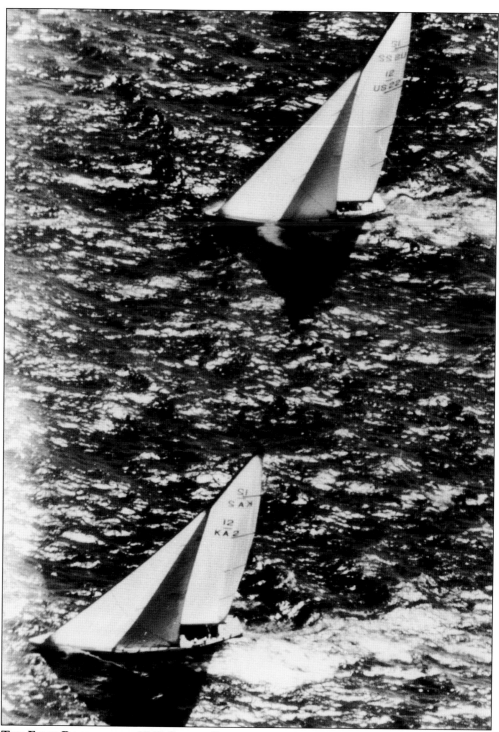

THE FIRST RACE IN THE 1967 SERIES, SEPTEMBER 12, 1967. Australia's *Dame Pattie* (KA2) and the *Intrepid* sail close hauled on starboard tack after crossing the starting line. The *Intrepid* is in the favored upwind position. (AP photo.)

THE *DAME PATTIE* (KA2), SEPTEMBER 18, 1967. On port tack, she sails under the stern of the *Intrepid*, in a futile struggle to battle her way to upwind of the defender in the fourth race of the series. The *Intrepid* was able to keep the favorable upwind position in the first leg of the 24.3-mile race. (AP photo.)

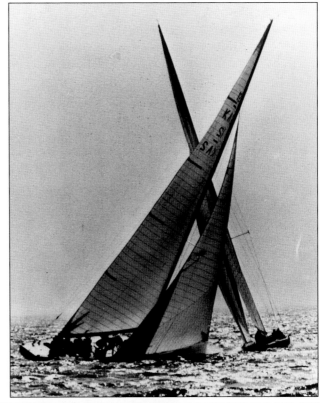

THE *INTREPID* SAILING PAST A REPLICA OF THE SCHOONER *AMERICA*. The new yacht *America* was built in 1967 in West Boothbay, Maine. (AP photo.)

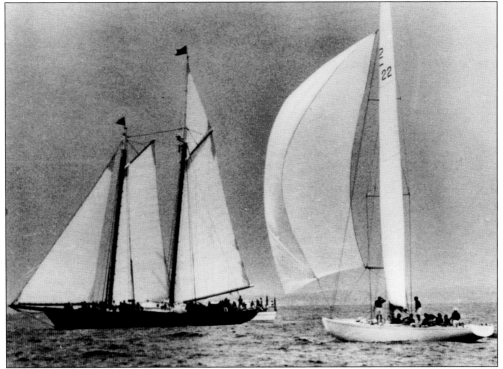

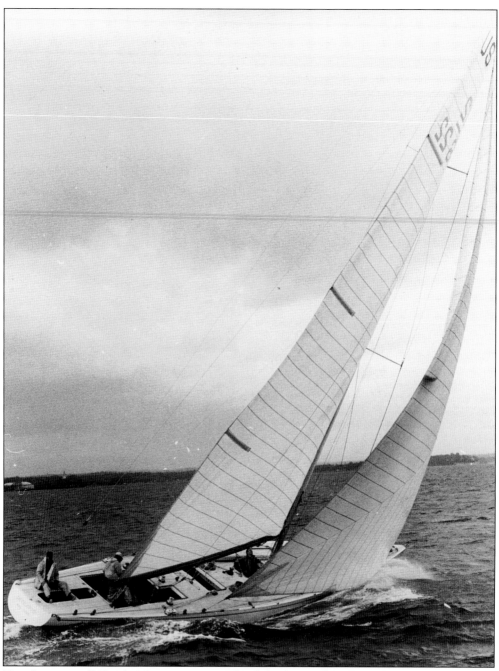

THE *INTREPID* (US22), MAY 26, 1970. The defender in the 1967 races, the *Intrepid* heels in rough weather during a test run from City Island, New York, to Stamford, Connecticut. Skipper Bus Mosbacher likened his 11-man crew to that of a football team. Just as a football team practice and work together, so the 12-meter team must have split-second timing and an intuitive knowledge of what the man next to him is doing at any moment. (AP photo.)

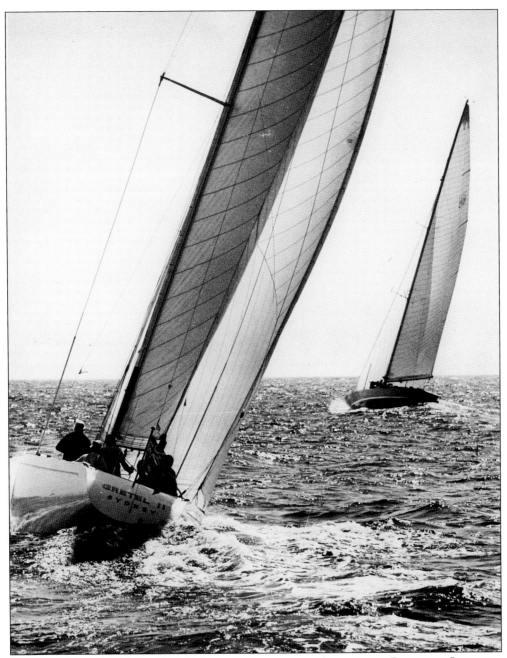

THE AUSTRALIAN CHALLENGER *GRETEL II* (FOREGROUND), AND THE DEFENDER *INTREPID*, **1970.** The *Gretel II* won the second race, but she was disqualified for a foul after the starting signal. She won the fourth race to tie at two wins each, but the *Intrepid* won the fifth race by one minute, 44 seconds. Later, *Mariner* skipper Ted Turner remarked, "*Gretel II* is a good example of a faster boat that lost. All you have to do is be one percent faster and you should have it made."

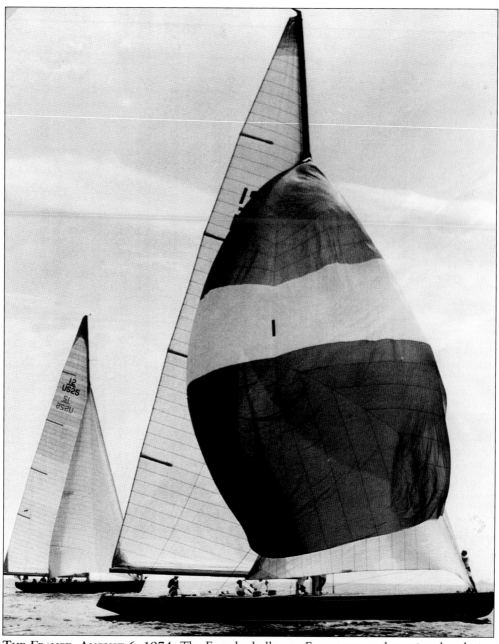

THE FRANCE, AUGUST 6, 1974. The French challenger *France* puts up her spinnaker during practice sail in Narragansett Bay. In the background is the newly rebuilt American yacht *Mariner*, one of four that vied to defend the Cup in the 1974 races. (AP photo.)

THE 1974 ELIMINATION RACES. The American 12-meter yachts *Intrepid* (US22) and *Courageous* (US26) battle at close quarters shortly after the start of the round robin series of elimination races. In this race, the *Intrepid* defeated the *Courageous* by 31 seconds. (AP photo.)

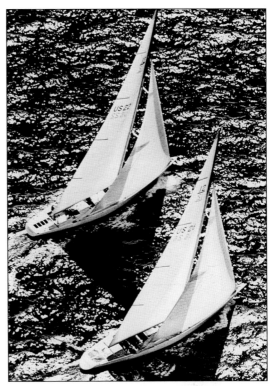

THE COURAGEOUS. In 1974, the *Courageous*, skippered by Ted Hood, won four out of seven races against the *Southern Cross*. In 1977, Ted Turner drove the *Courageous* to win four very close races against the *Australia*. The *Courageous* also competed in 1980, 1983, and 1986, but did not qualify for the finals. She is the first American 12-meter to be built of aluminum, and was launched in 1974 at City Island, New York. (Photo from a souvenir poster.)

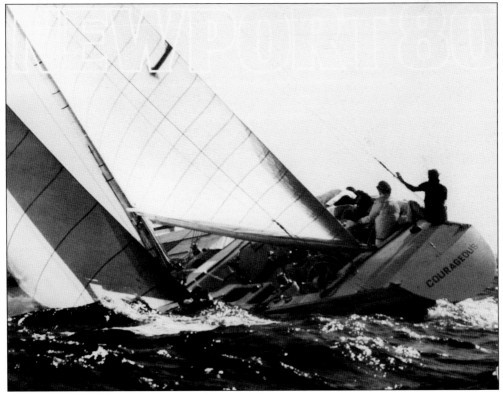

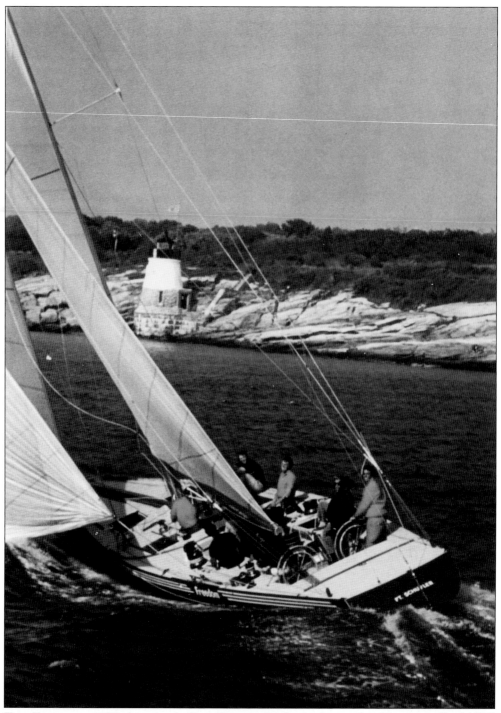

THE *FREEDOM*, 1980 AMERICA'S CUP POSTER. In the background is Newport's Castle Hill Light. In 1980, the *Freedom* triumphed over the *Australia*.

A SYDNEY OPERA
HOUSE POSTER
COMMEMORATING THE
AUSTRALIA II'S 1983
CHALLENGE FOR THE
AMERICA'S CUP
IN NEWPORT,
RHODE ISLAND.

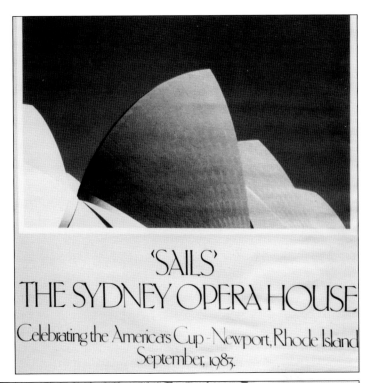

'SAILS'
THE SYDNEY OPERA HOUSE
Celebrating the America's Cup - Newport, Rhode Island
September, 1983.

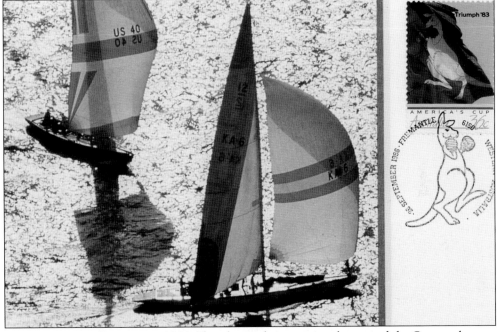

AN AUSTRALIAN POSTCARD, 1983. Taut, breeze-hungry spinnakers speed the Cup combatants through a silvery sea. The *Australia II* and the *Liberty* battle for supremacy in the 1983 challenge in the waters of Rhode Island Sound. Here, the *Australia II* holds a slight edge as she fights to win. The stamp on this franked postcard is inspired by the *Australia II's* battle flag, a combative boxing kangaroo.

A VICTORY POSTCARD, 1983. A puff of smoke is discharged from the cannon on board the committee boat, proclaiming a victory for the *Australia II* in the 1983 challenge for the America's Cup, ending the longest winning streak in any sporting event. Seven races were sailed in the waters off Newport, Rhode Island; when the *Australia II* evened the score by winning the sixth race, the scene was set to a finale destined to re-write sports history books.

THE *AUSTRALIA II* ON A 1983 POSTCARD. The *Australia II* flew through the water on her innovative winged keel, a major factor in winning the America's Cup in 1983. On the stamp, the world's most coveted sports trophy is held triumphantly aloft.

124

A Hot Collectable. This poster greeted Cup challengers when they visited Fremantle, Western Australia, for the 1987 struggle. A note in fine print reads, "May be protested by the New York Yacht Club."

A Souvenir Postcard, 1987. The first step in challenging for the America's Cup is to win the Louis Vuitton Cup, contested by all competing foreign yachts. A series of round-robins reduced the field to two: the New Zealand contender KZ-7 and the American yacht *Stars & Stripes*, skippered by Dennis Connor. Connor has the dubious distinction of being the skipper who lost the Cup to Australia in 1983.

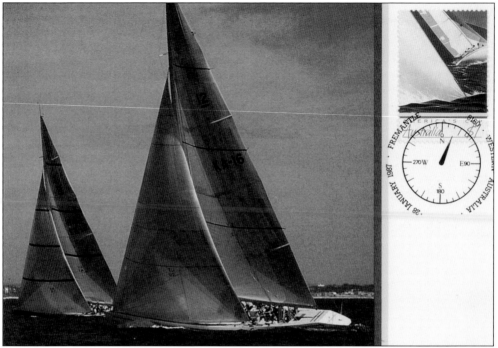

THE CUP IN AUSTRALIAN WATERS, 1987. The *Australia IV*, representing the Bond Syndicate, and the eventual defender, the Parry Syndicate's *Kookaburra III*, are seen sparring here.

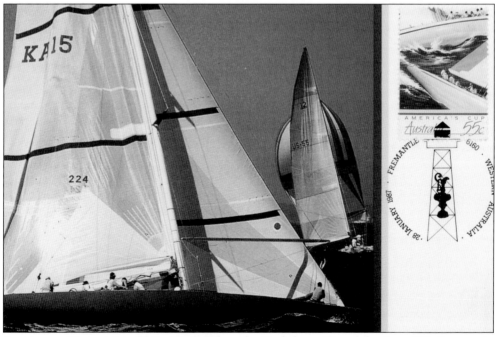

AUSTRALIA VERSUS THE U.S., 1987. When the *Kookaburra III* and the *Stars & Stripes* met in 1987, it was the seventh time yachts representing the U.S. and Australia vied for the Cup. On this occasion, however, it was the Australian yacht that was the defender—and the venue had changed from Rhode Island Sound to the waters off Fremantle, Western Australia.

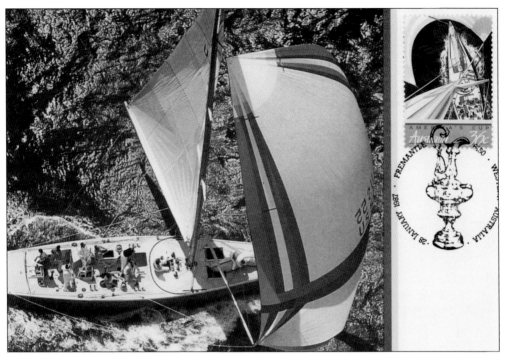

THE STARS & STRIPES, 1987. Skippered by Dennis Connor, the *Stars & Stripes* won four straight races. Connor vindicated himself by regaining the covered trophy he lost in 1983.

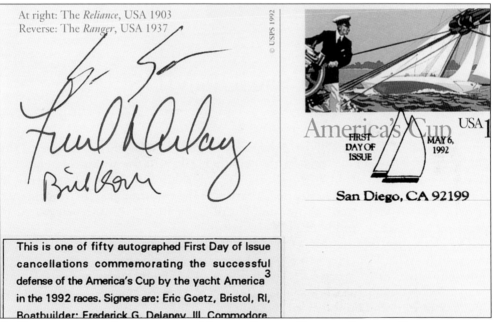

At right: The *Reliance*, USA 1903
Reverse: The *Ranger*, USA 1937

© USPS 1992

America's Cup

FIRST DAY OF ISSUE

MAY 6, 1992

USA 1

San Diego, CA 92199

This is one of fifty autographed First Day of Issue cancellations commemorating the successful defense of the America's Cup by the yacht America3 in the 1992 races. Signers are: Eric Goetz, Bristol, RI, Boatbuilder; Frederick G. Delaney, III, Commodore

A FRANKED AND AUTOGRAPHED UNITED STATES POSTAL SERVICE COMMEMORATIVE POSTCARD CELEBRATING THE SUCCESSFUL DEFENSE OF THE AMERICA'S CUP BY THE AMERICA3 IN 1992. The signatures are those of Eric Goetz of Bristol, Rhode Island, builder of the winning yacht; Commodore of the San Diego Yacht Club Frederick G. Delaney III; and Skipper-Owner Bill Koch.

Richard V. Simpson, a non-sailor, is a Rhode Island native. He moved to Bristol in 1961. His interest in the America's Cup began in 1967 while he was working in Newport during the height of the *Intrepid-Dame Pattie* competition for the Cup.

AMERICA'S CUP MUSEUMS

The Museum of Yachting, Fort Adams State Park, Newport, RI, brings to the public the beauty and excitement that has led sailors to the water for centuries. It is a lively organization that reflects the international flavor of yachting in Newport, and is dedicated to the preservation of the traditional skills, documents, vessels, and artifacts that record and describe the history and development of yachting in Newport and Narragansett Bay.

The Herreshoff Marine Museum, Burnside Street, Bristol, RI, was established by A. Sidney DeWolf Herreshoff and Rebecca Chase Herreshoff in 1971. The museum's goal is to perpetuate and display examples of indigenous Rhode Island technology and creativity. After some three decades of acquisition, documentation, and restoration, the museum exhibits 45 significant boats and historic records of the legacy of the Herreshoff Manufacturing Company.

The America's Cup Hall of Fame, Brunside Street, Bristol, RI, was created in 1992 to honor the legendary personages, defenders, and challengers of the world's oldest competition in sport. It is located on the exact site that so many defenders were planned, built, and launched.